APERTURE

SHARED LIVES: THE COMMUNAL SPIRIT TODAY

In North America, there has been a resurgence of "intentional communities," from small cooperatives on university campuses to large rural farming communities. When *Aperture* realized that a number of photographers were focusing on this subject, we also found that the question, what is communal, offered a wide range of interpretations. In this issue, we present six communities where people have chosen to share the labor and rewards of group living. The reasons for making this choice vary considerably, but there is a common theme among them. In each instance, people are committed to satisfying the needs of the group before those of the individual, with the belief that the individual becomes stronger in the process.

Alternative-lifestyle communes that sprang up during the 1960s have given the counter-culture movement—and communes—an indelible place in the social and visual history of North America. What quickly became clear, however, is that communal living claims a long history here.

For the first settlers arriving from Europe, it was a way of life rooted in the passionate commitment to building communities free from social and religious persecution. By combining their resources (which were often meager) settlers stood a better chance of surviving in the wilderness and cultivating the land.

Utopian experiments such as Amana and the Shaker communities flourished during the nineteenth century; many of these groups were formed in response to the misery of life in overcrowded industrial towns. Called "communistic societies," they offered poor people an alternative to slaving for factory owners who viewed their workers as an endless pool of cheap labor. It was a risky choice to make; there were no guarantees that any group could serve the economic needs of each individual and family. But the Utopian movement swept tens of thousands into new settlements across the continent, and many of these communities flourished for generations because they did offer the rewards promised. Although the original Utopian communities have all but disappeared, the concept of a society free of poverty and suffering continues to inspire many who strive for the personal and spiritual harmony that group living can afford.

We open this issue with Laura Wilson's compelling photo essay on the Hutterite communes of Montana. This is truly a world apart, where social and religious traditions formed in the sixteenth century still hold sway—alongside the latest innovations in mechanized agriculture. As Wilson shows in her text, the communal way of life is difficult but rewarding, and provides a wholesome rhythm of labor, relaxation, and worship.

Cristina Salvador's stirring visual narrative reveals the hidden domain of California Gypsies. Continuously persecuted since they dispersed from India one thousand years ago, the Roma's vigorously guarded ethnic heritage provides a vital sense of community for people who remain geographically scattered in order to survive. Salvador's images offer a memorable view of a society where non-Gypsies are rarely welcomed.

In New York City, Margaret Morton encountered a tiny village built by homeless Puerto Ricans on the Lower East Side. Her photographs chronicle the evolution of "Bushville" from a series of ramshackle cabins to what became a place of pride. The oral histories she recorded convey the hopes and despairs of homeless individuals who had found a place—until their hamlet was demolished on orders from Mayor David Dinkins.

Camphill Villages provide an alternative to the bleakness of institutional care for people with developmental disabilities. Camphill mutually engages the disabled and the able in a secure life where the healing process is intertwined with a communal way of life. The images here were taken by two accomplished photographers who live among and care for "villagers."

For the Old Colony Mennonites of Mexico, strongly-held religious beliefs have proved to be a double-edged sword. While tradition binds these farming communities together, their rejection of modern ideas has left them poverty-stricken and landless. Larry Towell's luminous photographs and narrative express the joys and sorrows of these migrant farmers who eke out a living "with God at the end of a hoe."

The issue concludes with Eugene Richards's intimate photo essay on Alpha Farm, where sixties-style idealism sustains a small Oregon commune founded twenty-five years ago. For one man, Alpha promised "a more significant life, the family he didn't have, a community of like-minded people . . . in which everyone would be social and economic equals."

Today, a broad spectrum of group living colors the domestic landscape—from religious sects in rural compounds to cosmonauts aboard Russia's space station, Mir. Here, we take an opportunity to observe people who invoke the traditional communal spirit—and create an experience that can be more rewarding than that offered by single-family life. In the process, they build a strong sense of community that often helps them overcome serious difficulties. We are indebted to the contributors who gave life to this publication, and to the individuals who welcomed these photographers into their circles.

THE EDITORS

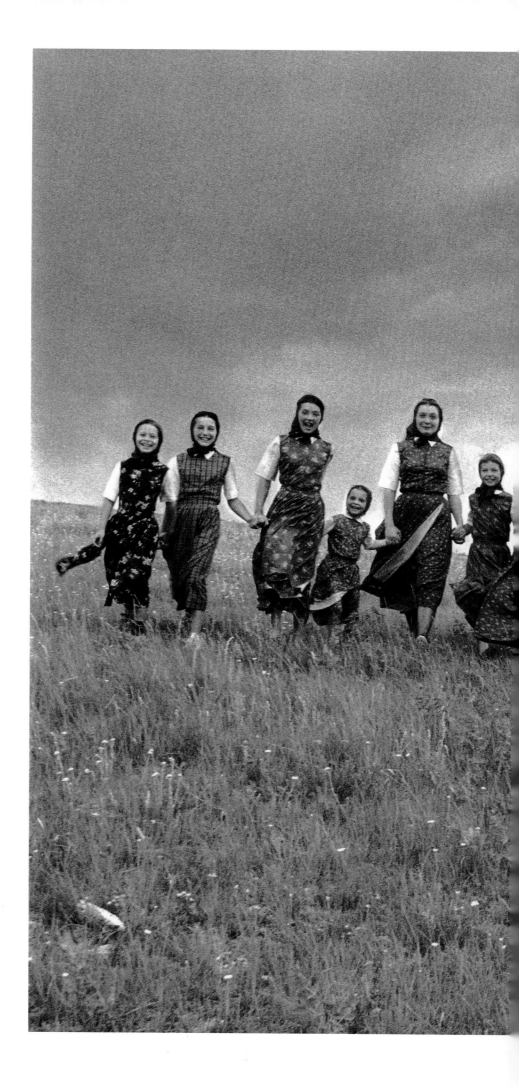

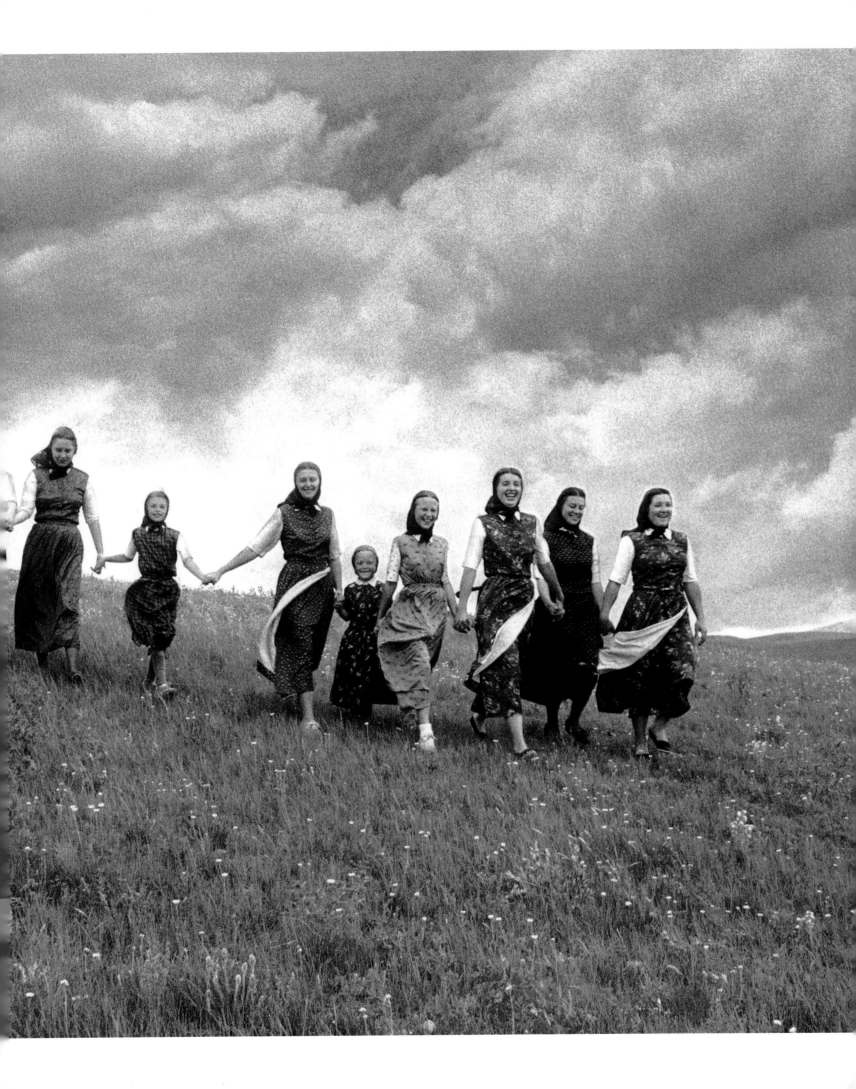

THE ENCLOSED WORLD

PHOTOGRAPHS AND TEXT BY LAURA WILSON

> There is a sense of well-being that comes from having a clear sense of life's meaning, and a wholesome rhythm of labor, relaxation, and worship.

Far from the unpredictable currents of mainstream America, across the wide prairies of Montana, the Hutterites live on large farms and ranches. Here, in self-contained colonies of thirty-five to one hundred or so people, they shun the modern world. The values embraced by most of this country—personal freedom and financial ambition—are not their values. In an America that has been urbanized, industrialized, and bulldozed out of direct contact with the earth, the Hutterites know what to love. They have hung on to their heritage and abided by their religion. They have turned away from contemporary America more vigorously than even their spiritual cousins, the Amish and the Mennonites: no TV, no telephones, no cars, no dancing. And, in this murderous century, they are pacifists.

Olive Losee, a rural nurse in Montana for more than fifty years, took me to Springdale Colony in 1986. We knocked on the door of Sara Wipf, a Hutterite midwife. Olive and Sara talked shop. "Spit has many uses," they agreed. "Just a little spit on your finger will clean a newborn baby's eyelids." I hesitated to ask to photograph because the Hutterites forbid photography. It is considered vainglorious. So Olive Losee and I made two more trips without taking a picture. Slowly, I began to make friends and build trust. When I started to photograph, the Hutterites understood that I did so to affirm the values of family and spiritual life in their enclosed world.

The Hutterites originated in Moravia in 1528, and survived over three centuries of migrations and hostilities before coming to the prairies of America in the 1870s, to look for land, religious freedom, and exemption from military service. During both World Wars, however, hostilities again plagued the Hutterites when zealous patriots harassed and tormented them for their refusal to fight in defense of their adopted country. Two Hutterite men, who had served sentences for refusing to be conscripted into the army during World War I, died in Alcatraz. Another wrote home from an army camp in Washington, "My tears ran down my cheeks as if to make a flowing river. The hurt is unbearable at how cruel people can be." Only since 1945 have the Hutterites been allowed the status of conscientious objector in the United States.

Separated from worldly entanglements by the geographic isolation of Montana, the Hutterites today live in communal groups, speak to each other in a German dialect, and share all possessions and goods. This communal way of life is central to the Hutterites' existence. Not only is it an economic requirement, it is a spiritual obligation as well. Each person is expected to support and serve the colony that supports and sustains him. Since God created all things for common use, communal life expresses God's will. The individual constantly subordinates himself to the common good; everyone works according to his ability, and receives according to his need. Neither men nor women earn wages. All profits from the sale of wheat, barley, hogs, cattle, poultry, and produce are used to pay colony expenses. Any surplus is saved for the purchase of additional land, which will eventually be home to another Hutterite community.

The hours and rhythm of every Hutterite's day are dictated by the colony. All tasks are assigned. Women work together gardening, cleaning, sewing, house painting, or preparing food. Men work with cattle, hogs, dairy cows, poultry, or in the machine and carpentry shops. "Community life is hard," a colony minister told me, "but you know you'll never have to peel potatoes by yourself." Work times, meal times, worship, and rest times are all scheduled, and repeat the same pattern day after day. Farm labor is one of the great benefits (rather than costs) of a Hutterite operation. It keeps the boys and men on the place. An agricultural life sets reassuring boundaries of rhythm and routine. Planting and plowing. Year in and year out.

When Eudora Welty photographed in the rural South during the 1930s, certain truths, she said, became "ever so clear and plain" to her. And it became clear to me after my first trip to a Hutterite colony that these people are raised with a strong sense of belonging to the land and to each other. Old people are never sent to nursing homes. Everyone eats in a communal dining room, the

Pages 2–13: Laura Wilson, from the series "The Enclosed World," 1987–1996

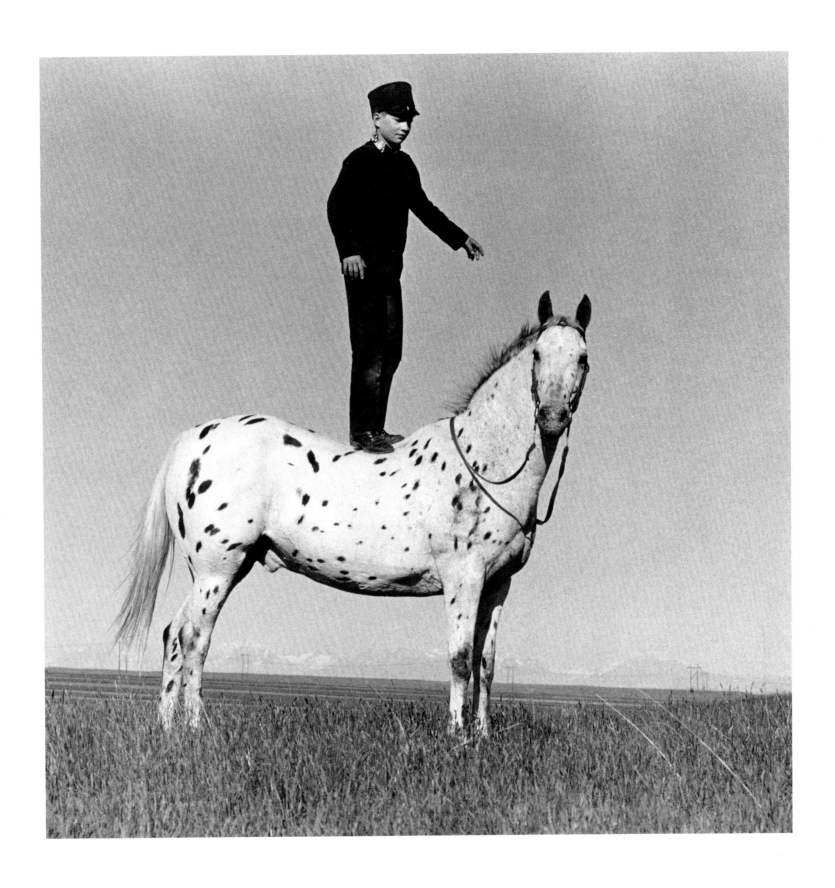

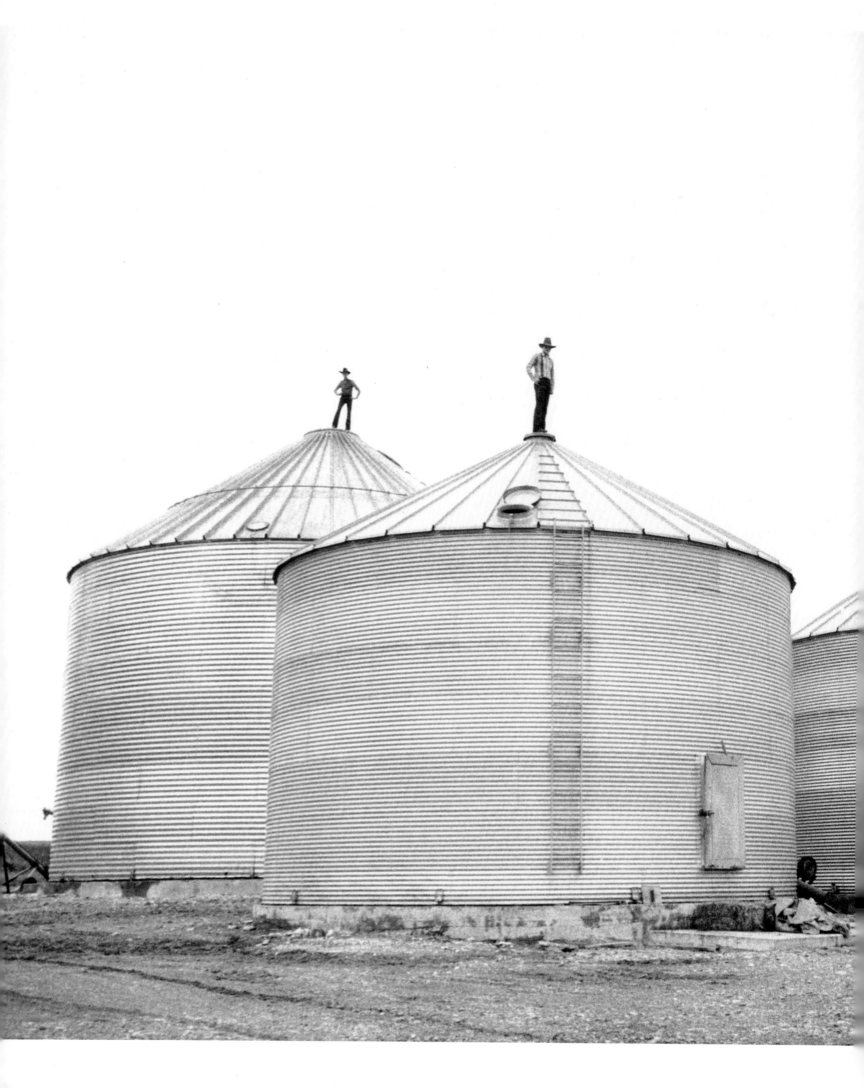

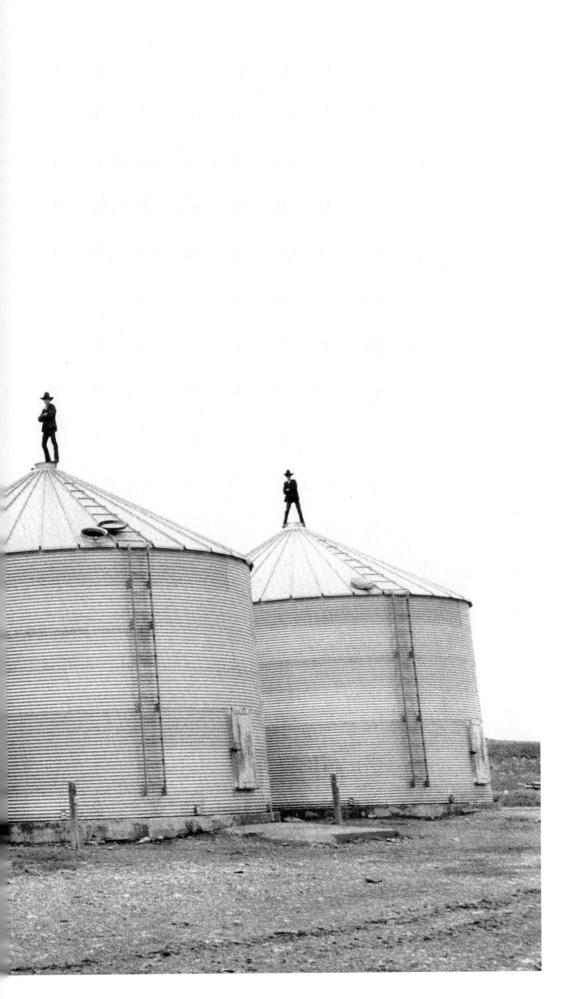

men at one long table and the women at another. Colony houses are connected and no one knocks to enter. In a house full of sewing and hymn singing, one of five daughters told me, "Mother says we're her radio."

Hutterite boys and girls are taught by a public school teacher brought into the colony. Students meet normal state requirements through the eighth grade or until they reach age sixteen, whichever comes first. Each day, both before and after public school, a Hutterite man teaches "German School." Here, every child from age six to fifteen receives moral and spiritual instruction. Formal education is considered unnecessary beyond the eighth grade, as it is thought to operate against communal life. When school ends, young people join the adults in their work. Teenagers are allowed to be immature but they are not permitted to be antisocial, to do their work poorly, or to show disrespect for authority. "Don't think our life is a bed of roses," a Hutterite father told me. "We have the same problems you have out in the world." To some extent, this may be true, but there are no Hutterites in jail, and there has never been a homicide. There is no divorce or abortion in a Hutterite colony. As for adultery, I was told, "We preach against it everyday."

Hard work is essential to colony life. "I came here to this place thirty-nine years ago," said Joe Stahl, the tough, shrewd seventy-five-year-old farm boss of Surprise Creek Colony. "Came here with three boys, two were fifteen, one was fourteen. We worked twenty-two-hour days. We worked so hard I didn't know if the sun was coming up or going down. I was delirious. In winter, it would be forty-two degrees below zero. Blinding snowstorms. But at the end of three years, we'd paid off the money we borrowed in Billings and we owned 7,200 acres. Now we have 15,000 acres." With farms and ranches all over America going under, the Hutterites have shown a remarkable ability to adapt to the scorching sun and freezing temperatures of the Montana

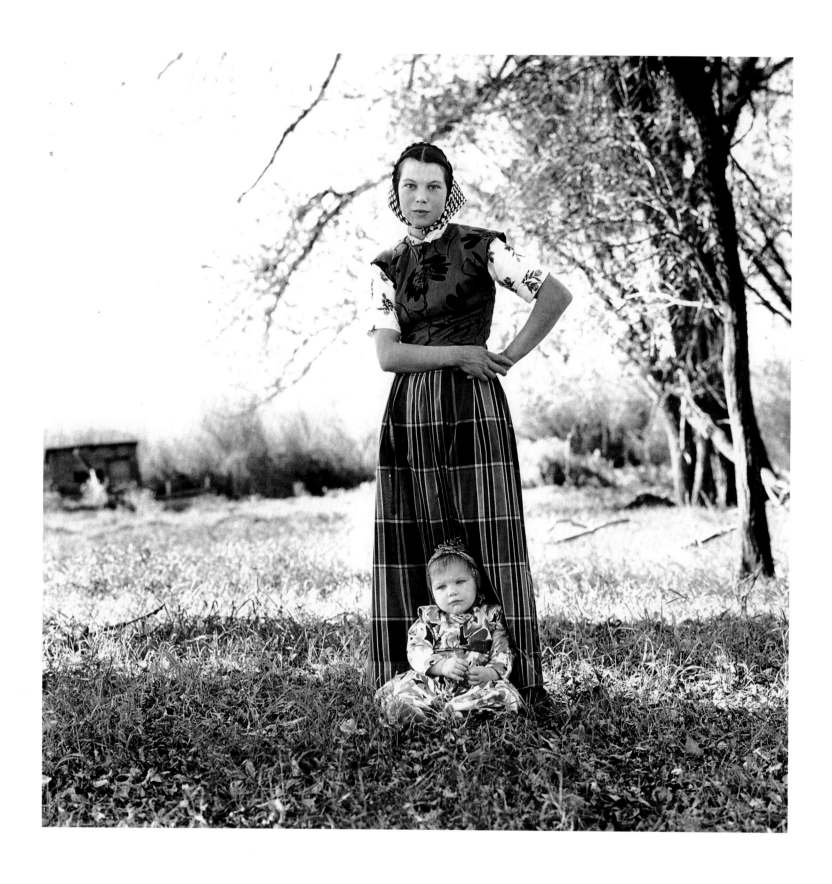

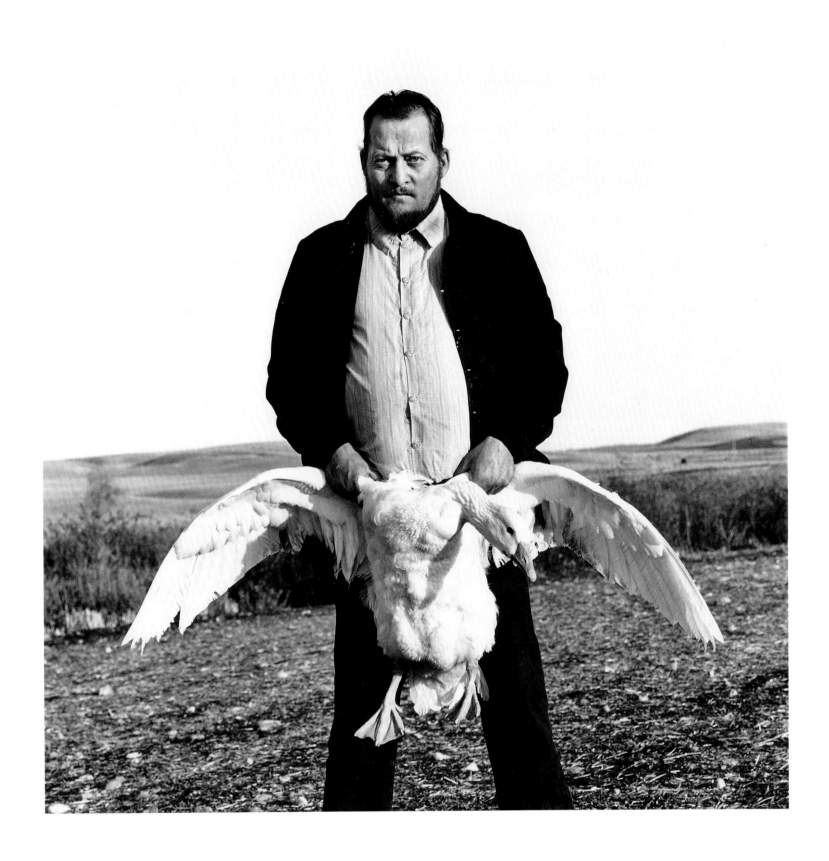

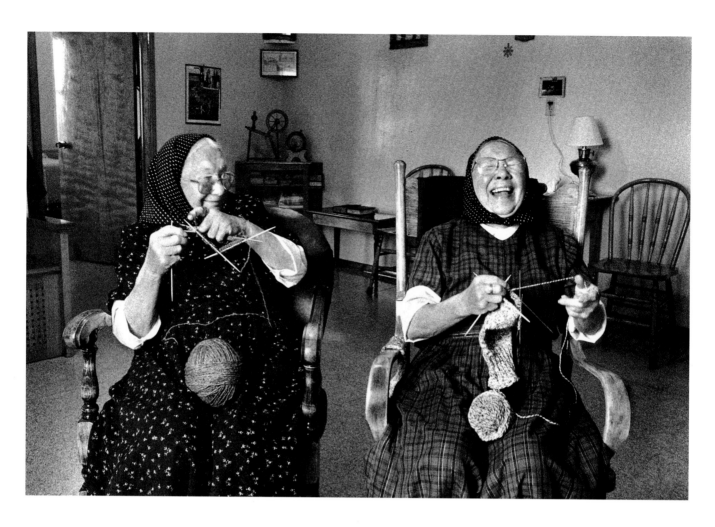

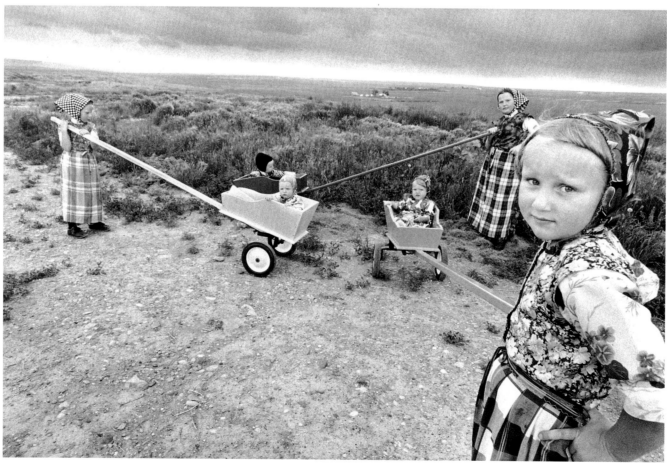

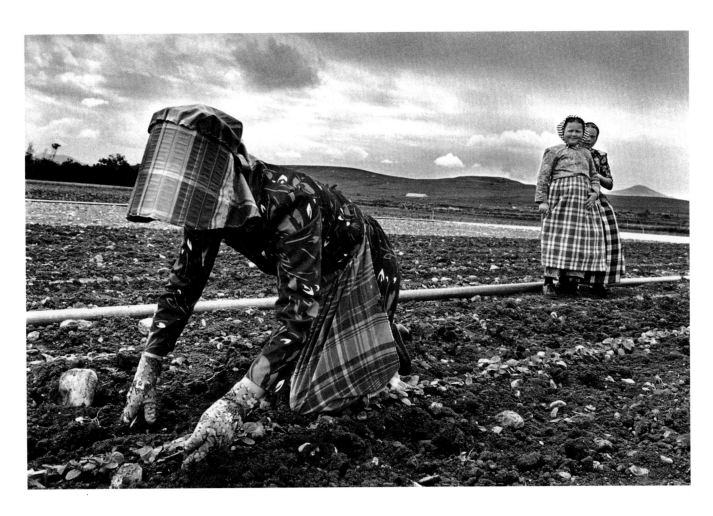

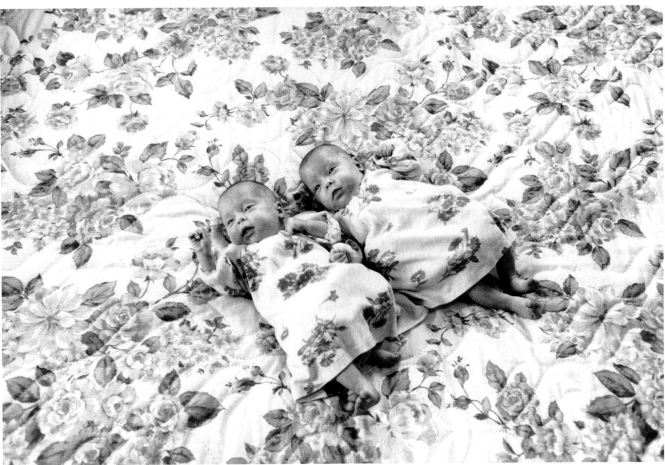

prairie. By combining their highly skilled, unpaid labor force with the most advanced agricultural equipment, the Hutterites are able to stay abreast of the competition. As progressive farmers and ranchers, they differ sharply from the Amish in that they see no spiritual conflict in using the most advanced machinery. Agricultural innovation and use of the best equipment benefits the community and supports the welfare of the colony. Although there is a repetitiveness to Hutterite life, the communal character of all activity makes work social, genial, and sometimes even festive. Due to the efficient organization of labor, and because of their equitable allocation of resources, there is less pressure, anxiety, and self-concern.

Lyn Mattoon, a teacher who has done field work in rural communities in the United States, joined me for a two-week visit to several colonies. "What impresses me about the Hutterites," Lyn said, "is how successful they are in meeting the basic challenges facing communities everywhere: how to give people security, meaning, social and work satisfaction, and how to deal with human weakness."

There is a sense of well-being in the Hutterite colonies that comes, perhaps, from having a clear sense of life's meaning, the closeness of friends and relations, and a wholesome rhythm of labor, relaxation, and worship. This is not to say that the Hutterite way is perfect. Once in a while a boy will get a whiff of the outside world. When he was twenty-two, the hog boss of Golden Valley Colony left for thirteen months. I asked him where he went and what he did. "I went to Denver," he said, "and what I saw there, I shouldn't have seen. I learned what it takes to survive without the support of the Colony." Then, glancing at his wife, "She brought me back. I came home to marry Annie." He continued, "We know our history, what our elders suffered. I think I owe it to them to keep the culture they started for us. And the only way we can hold on to our culture is to be separate from the world. You build a fence around a beautiful field of grass."

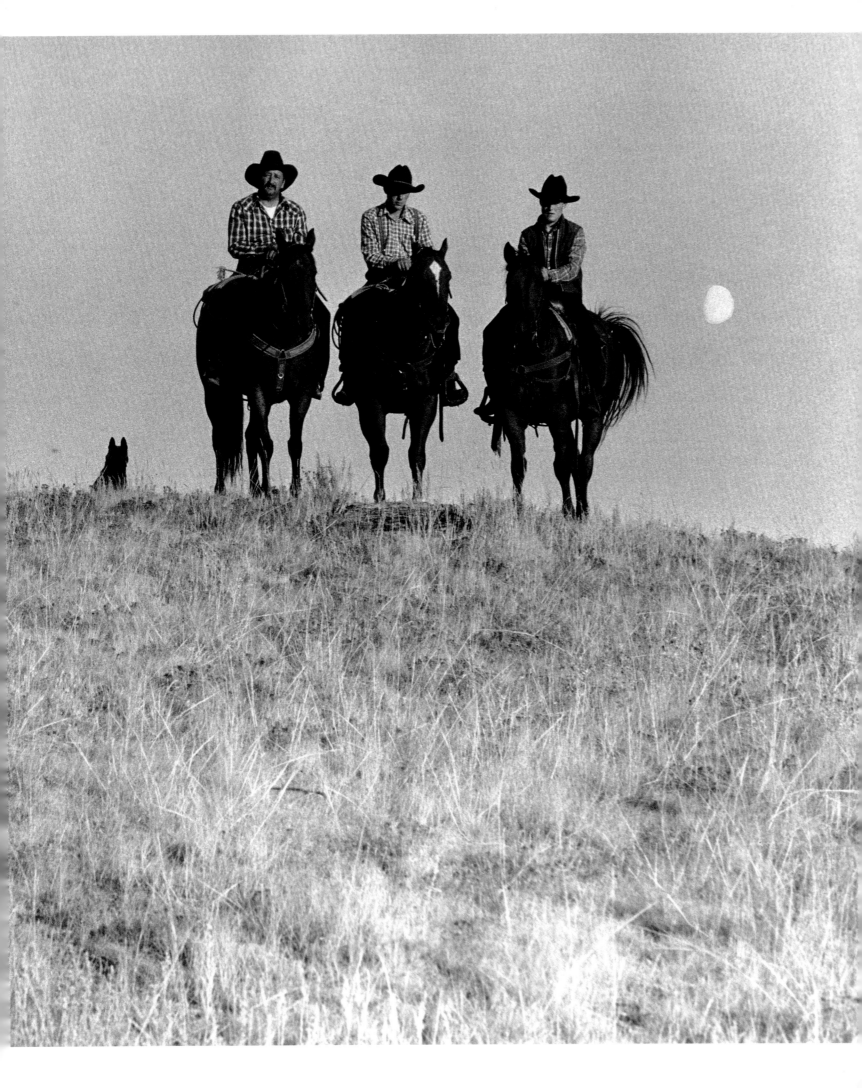

AMERICAN ROMA: THE HIDDEN GYPSY WORLD

BY IAN HANCOCK

PHOTOGRAPHS BY CRISTINA SALVADOR

Practically invisible in the rich ethnic mix that makes up this country, the Romani Americans, or "Gypsies," are found in every major city, and continue to maintain their language and cultural identity with a vigor other minorities might envy.

Popular ideas about Gypsies are mixed. Since very few Americans know any Gypsies personally, most still believe Gypsies to be fantasy figures rather than real people. Romanticized characters like Carmen and Esmeralda and Heathcliff, or songs such as Cher's "Gypsies, Tramps and Thieves," or Hollywood movies such as *Wild Gypsies*, *Gypsy Hot Blood*, and *Golden Earrings* have permanently etched these images into the cultural and social consciousness. Far more insidious are the widespread beliefs that "Gypsies are thieves," that "Gypsies steal babies," and that "Gypsies can't be trusted." In January 1992, *The New York Times* published a poll that surveyed the attitudes of the general public toward fifty-eight different ethnic and racial groups in the United States over the last twenty-five years, and reported that Gypsies were perceived as the most "undesirable." This is surprising, because most Americans have no first-hand contact with Gypsies—and equally unsurprising, as historically, Gypsies have been harassed for being outsiders, for being wanderers, for their dark skin and "foreign" ways.

Many of these prejudices persist through institutionalized folklore that dates back to the medieval period and today, the belief that Gypsies are criminals has become entrenched. One of the most striking examples was a 1991 incident involving a St. Anthony, Minnesota store owner who mistook a group of Bulgarian diplomats for Gypsies and ejected them from the premises. In April of 1995, when CBS TV's *48 Hours* proposed a feature on Gypsies, one of its producers (who claimed to be sensitive to issues of ethnic bias) stated that she could not do a story about Gypsies without talking about crime—simply to open the subject of stereotyping. The examples are endless but the point is that in a population of over a million American Gypsies, it's as ridiculous to think that every one is a thief as it is to think all are gifted fiddlers.

Ironically, it is the persistence of these images that shields much of the real American Gypsy population from the outside world.

> One of the legacies inherited from India, and rigorously practiced in the United States, is the belief in ritual pollution, and in the importance of maintaining a spiritual harmony or balance in one's life—a balance which can easily be upset by not observing proper cultural behavior.

The Roma in the United States came here from Europe as many other emigrant groups did, yet comparisons end there. The Roma aren't Europeans but originated in India, and while they have lived in the West for nearly eight centuries, the heart of the language and culture is Indian. It is because of their status as outsiders that their experience in Europe has been so relentlessly harsh; arriving at the time of the Turkish takeover of the Byzantine Empire around the beginning of the fourteenth century, they were originally thought to be a part of the Islamic threat; they were particularly shunned because they had no homeland in Europe.

This nonterritorial status has dogged the Roma to this day, especially in regions where staking claim to one's own territory has led to ethnic cleansing and the fragmenting of the Eastern European map. While Slovaks now have Slovakia, Serbians Serbia, and Belorussians Belarus, the Roma, easily the largest and most widely dispersed ethnic minority in Europe, have no homeland and are consequently viewed as intruders on everybody's turf.

While it is true that the origins of Romani language and life are Indian, centuries of contact with Europeans and Euro-Americans have created a new syncretic population, both in genetic heritage and in culture. This being the case, it is truly remarkable that, a thousand years later and thousands of miles away from the homeland, Gypsies have retained so much of their original character. Their marginal status as outsiders, which has minimized access to mainstream society, has also helped sustain their cultural identity. Forbidden to attend school or participate in national life, the Roma existed on the fringes of European society. In southeastern Europe, they were enslaved for some five-and-a-half centuries, only being granted their full emancipation in the 1860s.

A second and equally significant reason for their strong ethnic identity is that traditional Romani culture (called *rromanipé*) does not permit involvement with the non-Gypsy world beyond the minimum required for social and economic survival. One of the legacies inherited from India, and rigorously practiced in the United States, is the belief in ritual pollution, and in the importance of maintaining a spiritual harmony or balance (*kintála*) in one's life—

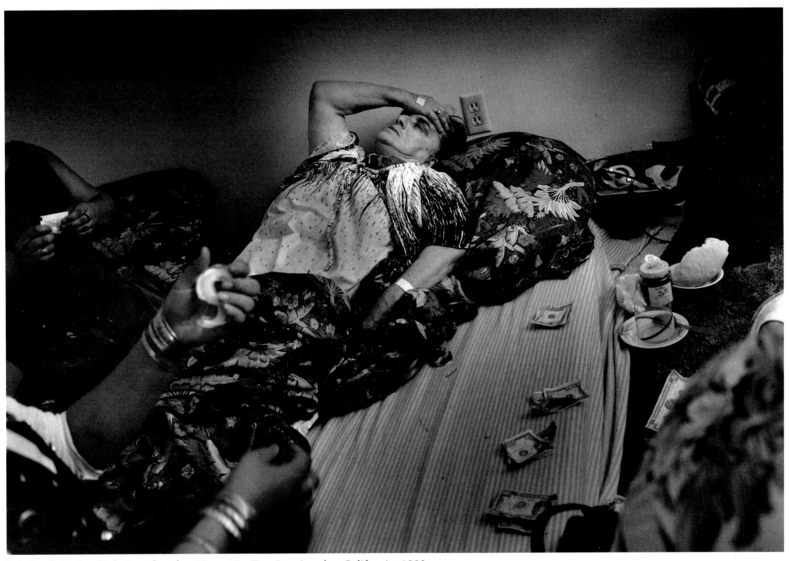

Cristina Salvador, *Sick Grandmother*, Xoroxaja, East Los Angeles, California, 1992

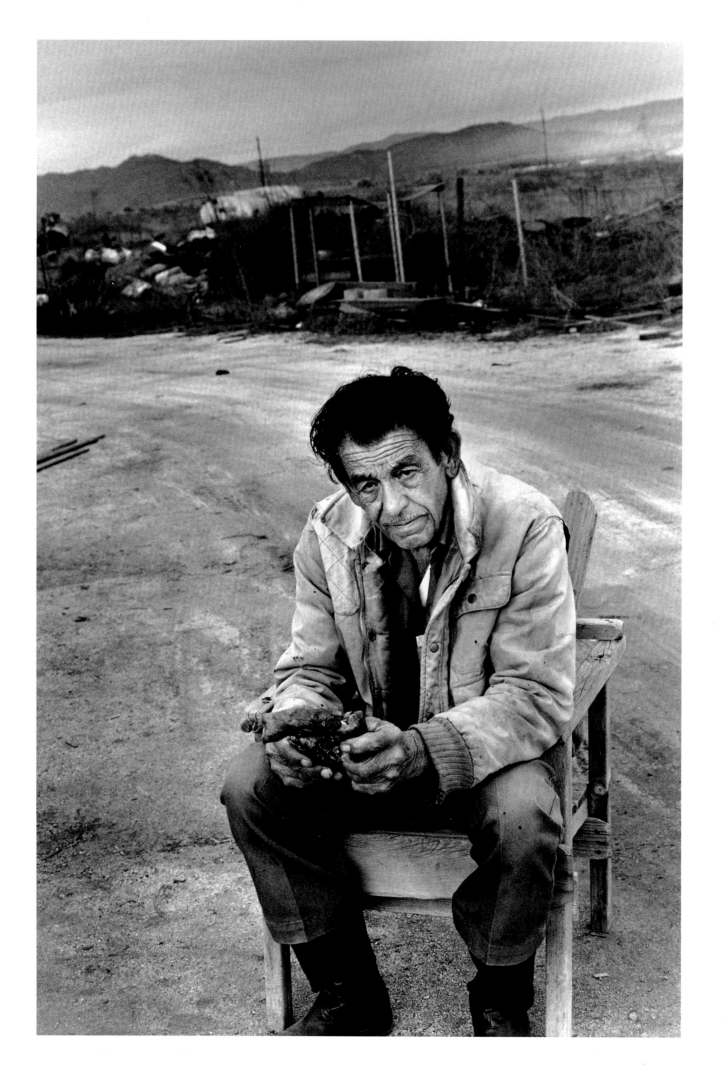

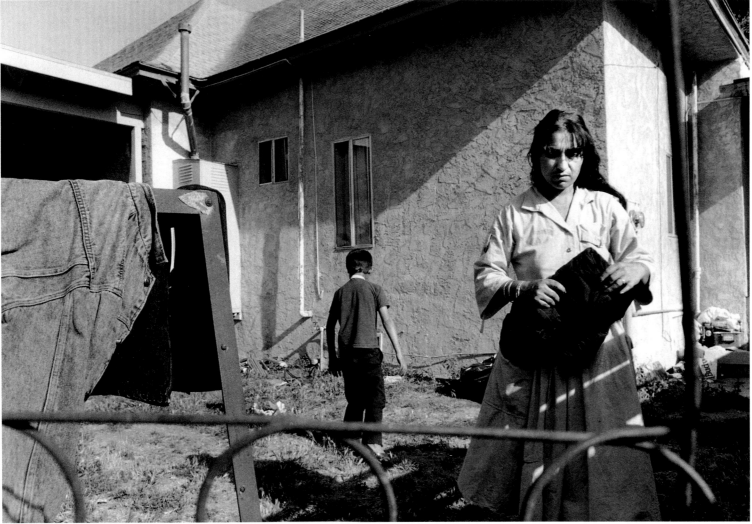

Opposite: Cristina Salvador, *Christmas Candle*, Ludar, Southern California, 1993
Above: Cristina Salvador, *Mother of Eight*, Xoroxaja, Paramount, California, 1991

a balance that can easily be upset by not observing proper cultural behavior. Socializing too intimately with non-Romani people (*gadjé*) is a serious transgression of this, which leads to defilement and spiritual disharmony, and perhaps to illness. Disdain for *rroma-nipé* can sometimes lead to banishment from the community. Even in countries where severe assimilation policies were enacted upon the Romani minority, such as in Hungary or Spain in the 1700s (where it was illegal to speak Romani or to call oneself a Gypsy, and where Romani children were removed permanently from their families and put into foundling homes or with white families) Romani identity thrives nevertheless.

Strong social bonds exist within the families because of a natural drawing together for protection, and because time spent among the *gadjé* is considered debilitating and upsetting to the natural balance of things; being with Roma redresses this, recharging the spiritual batteries. So fundamental to daily life is interaction solely within the Romani community, that in the Gypsy English ethnic dialect, "the public" refers not to the larger population but only to the members of the Romani community.

In the past, the Roma were able to sustain a livelihood by providing services to the non-Gypsy population, including metal-working, horse-trading, renovation, and repair. But these employment opportunities have declined due to technology. One occupation, fortune-telling, survives among some groups and continues to provide a decent income. But while this profession has prestige in India, here it is regarded with skepticism and often leads Gypsy fortune-tellers into conflict with the law.

It was the discovery of the Indian identity of the Romani language that first set Western scholars on the trail of Gypsy origins in the late eighteenth century. Common words—indeed well over half the entire vocabulary—are almost the same in both Romani and Hindi. But identifying the language didn't identify its speakers, and for the next two centuries, academics have been trying to answer some very basic questions: If the Gypsies came from India, who were they, when did they leave, and why? It was variously claimed that they were Egyptians (hence the word "Gypsy"), Turks, Jews, Africans, and even people from the moon. For over a century and a half it was believed that the first Gypsies were musicians given as a gift by the king of India to the Persian court in the fifth century. Today, mainly on the basis of linguistics and serological studies, it is believed by a growing number of specialists that the Roma descend from a composite population of non-Aryan Indians, and possibly from African mercenaries (called Siddis) in India, assembled in the eleventh century into a military force to repel the Islamic invasions led by

17

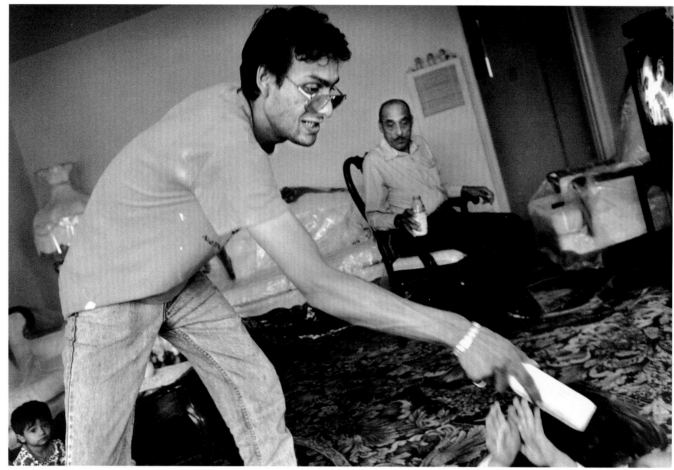

Above: Cristina Salvador, *Losing Control*, Kalderash, Long Beach, California, 1992
Below: Cristina Salvador, *Comfort in His Cousin's Arms*, Kalderash, Long Beach, California, 1990

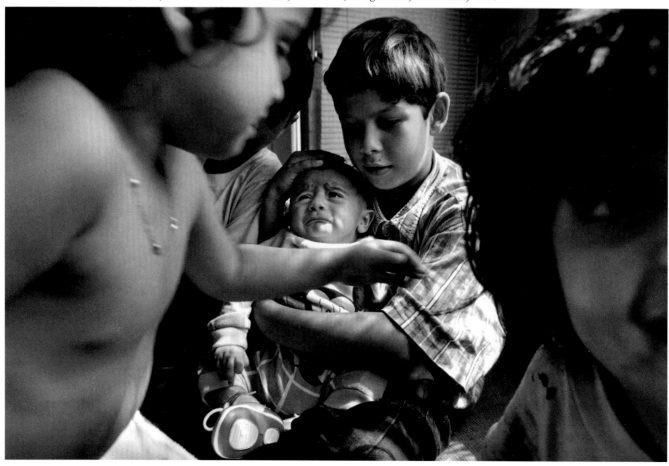

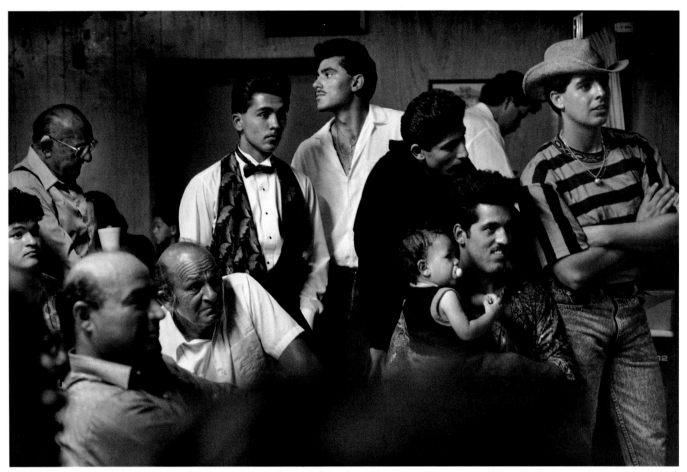

Above: Cristina Salvador, *Wedding Party*, Ludar, southern California, 1992
Below: Cristina Salvador, *Firing the Gun*, Xoroxaja, El Monte, California, 1992

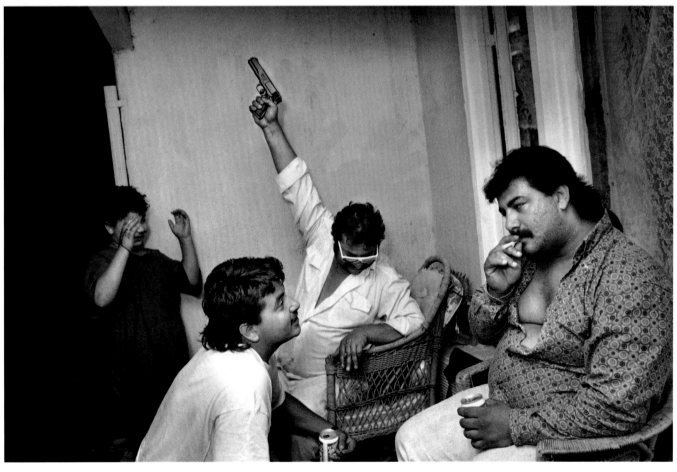

Mohammed of Ghazni. Moving further and further west in a succession of conflicts with the Muslims, the Roma passed through the Byzantine Empire in the thirteenth century and were pushed up into Europe as that, too, was occupied by Islam.

After arriving in Europe, hundreds of thousands of Gypsies were held in slavery in the Balkans, but others moved on into the rest of the continent, reaching every country there by 1500. And while the Roma in the east were used as a labor force, in Western Europe they were subject to strict legislation and kept on the move. In some places, attempts were made either to exterminate them or to assimilate them by force. The establishment of overseas colonies provided a useful dumping ground for this unwanted population, and from the very beginning the Spanish, Portuguese, French, Dutch, English, and Scottish governments began transporting Gypsies for slave labor to their colonies. Today, in Louisiana and Cuba, there are mixed Afro-Gypsy populations, which have resulted from intermarriage between the freed slaves in those places.

The most drastic example of European anti-Gypsyism took place in this century, when Gypsies, together with Jews, were singled out for annihilation as part of the Nazi's final solution. Both Jews and Gypsies had lost about the same percentage of their total number by 1945, but the fate of the Roma was not discussed at the Nuremberg War Crime Trials, and almost no reparations have been made to Romani survivors since then.

It is a mistake to think, as novelists and screenwriters tend to do, that Gypsies constitute a homogeneous population. As the migrating population spread out into Europe, the different groups became associated with different countries, over time acquired local characteristics, and intermarried with local populations. It is for this reason that Gypsies in Britain, Hungary, and Spain differ from each other in appearance and in the extent to which *rromanipé* has been retained or modified. This has led some scholars to regard the Roma not as one people but rather as a population of historically related but distinct ethnic groups.

The first Roma to come to America accompanied Columbus on his second voyage in 1498, and during the seventeenth century, small numbers arrived from different parts of Western Europe. The first major wave of Gypsies to come to the U.S., however, came from Britain in the mid 1800s, followed by a second influx toward the end of that century when slavery was finally abolished in Eastern Europe. The collapse of communism in 1989 led to a third big migration, spurred on by the reemergence of ethnic tensions in the Eastern European states. Landless, and constantly on the move, they lack any kind of political or military defense, making them an easy target for nationalist extremists.

There are about one million Romani Americans, though the census figures tell a different story. This is because Gypsies don't all answer the census form, or else don't report their ethnicity (a Roma from Serbia is likely to put "Serbian" rather than "Gypsy"). Also, when questioned as to their own estimates, individuals will refer only to their own group—a Russian Gypsy, for example, will not include the Hungarian-Slovak Gypsies in his estimation.

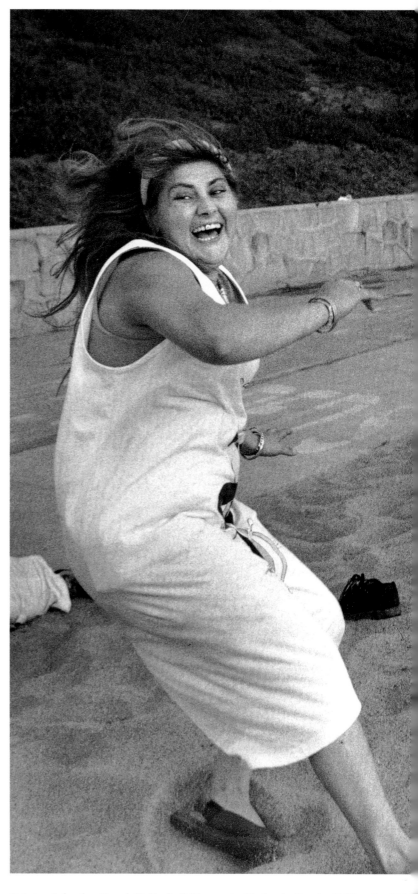

Cristina Salvador, *Beach Volleyball*, Xoroxaja, Redondo Beach, California, 199?

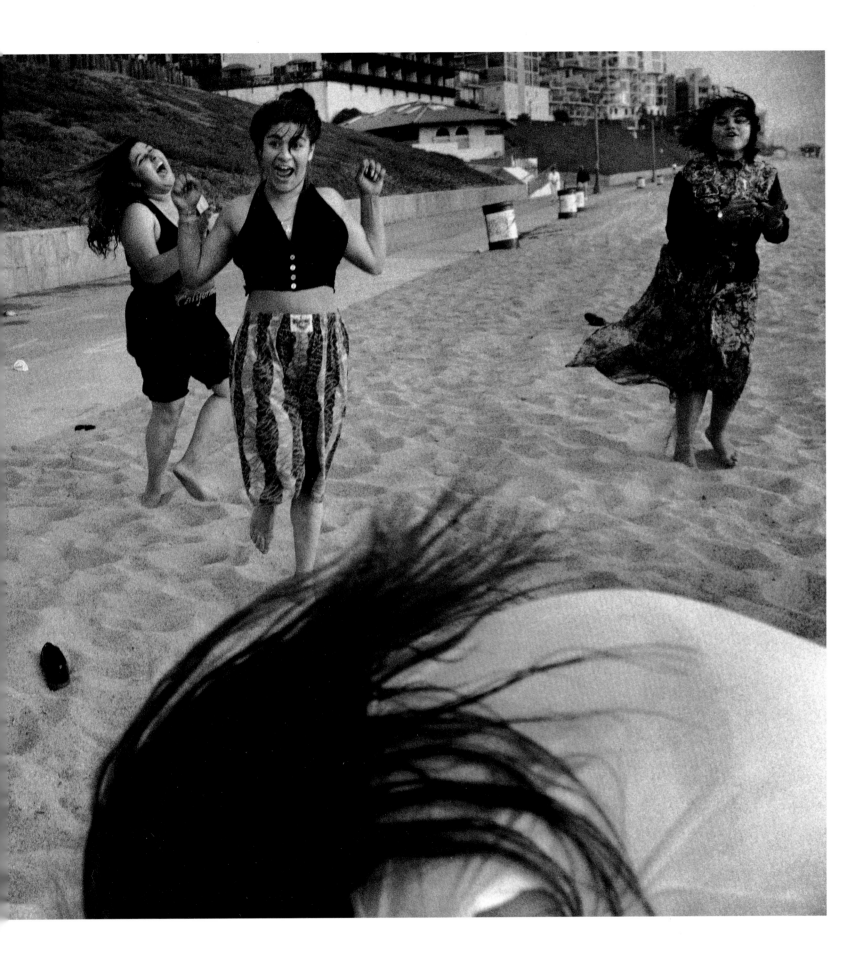

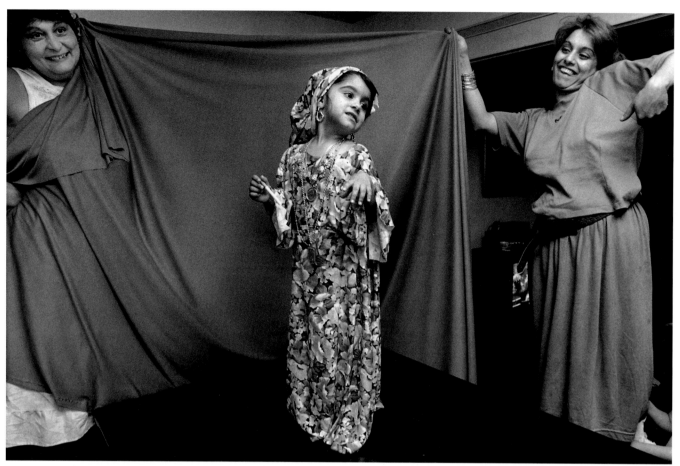

Above: Cristina Salvador, *Dressing Up Susie*, Kalderash, Long Beach, California, 1990
Below: Cristina Salvador, *Wedding Dance Floor*, Machvaya Wedding, Manhattan Beach, California, 1990

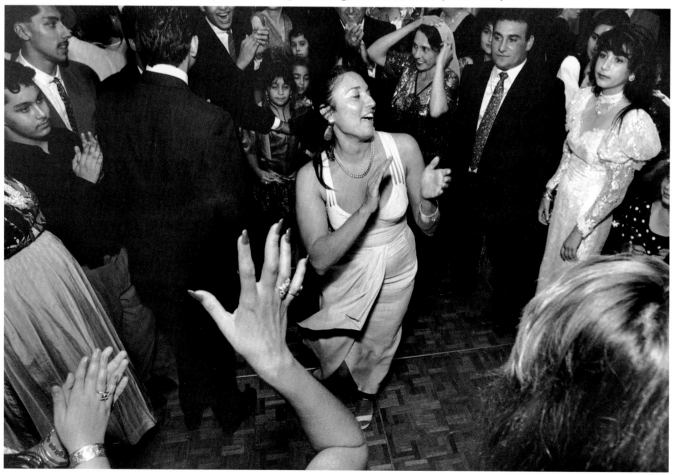

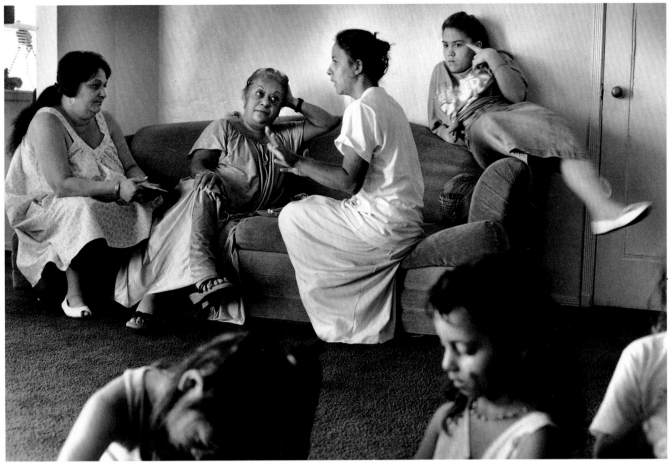

Above: Cristina Salvador, *Early Morning Gathering*, Machvaya/Kuneshti, Van Nuys, California, 1991
Below: Cristina Salvador, *Gypsy Music*, Kalderash, Long Beach, California, 1991

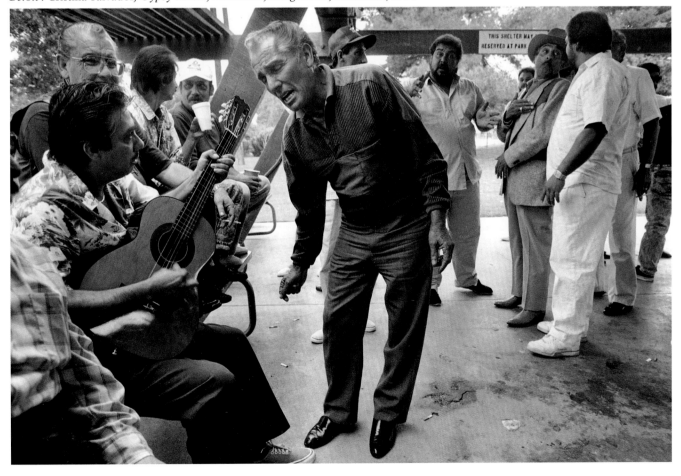

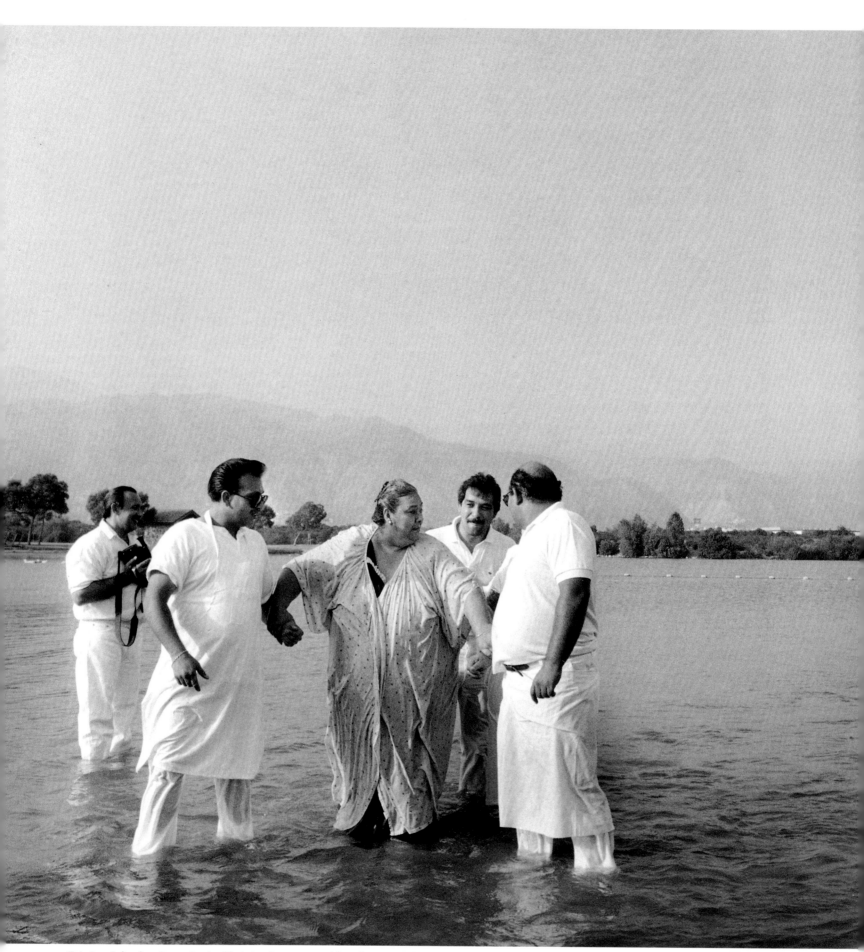

Cristina Salvador, *Born Again Christian Baptism*, Kalderash, Irwindale, California, 1992

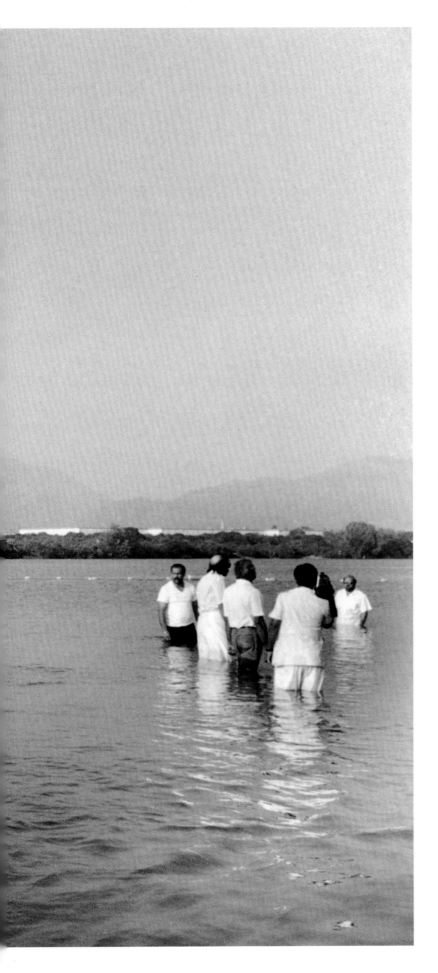

In this multihued society, it has been easy for Gypsies to "pass" as members of other groups, such as Mexican-American, Native American, or Greek. The camouflage is completed by having, in addition to an ethnic name for use within the community, an American name for use in dealings outside it; thus a woman known in the Romani community as *E Rayida le Stevoski* might be Rita Stevens to the rest of the world, and *O Vosho le Nikulosko* plain Walter Nickels. And they would both make sure to keep their true ethnic identity to themselves.

One of the largest subgroups in the United States is the Vlax Roma, descended from the slaves who were freed in Romania during the 1850s and 1860s. Those who could, left—some going east into Russia, some west into Serbia and Hungary, while others moved south into Greece. Most, however, lacked the means to go anywhere, and their descendants, over two and a half million strong, still live in Romania. The largest group of Vlax Roma from Serbia is the Machvaya, a name originating in the Machva region of eastern Serbia. The photographs here are mainly of Vlax Roma living in southern California.

Romani culture in the United States varies somewhat from group to group, but among the Vlax, the family and the community are central to daily life, and the maintenance of *rromanipé*. Although there are lawyers, filmmakers, police officers, politicians, restaurateurs, and teachers among the Vlax, such occupations are not common. Jobs having less direct involvement with the American establishment and also allowing freedom of movement are preferred. This is partly because of fear of defilement, and partly because it is important to be able to leave and visit another community at any time, for a wedding, a funeral, or a saint's day banquet. Communities are not usually clustered together because this would put the economic opportunities of the families in conflict. Religious festivals, particularly Christmas and Easter, are important, and for the Machvaya, these traditionally follow Eastern Orthodox rite.

As with all ethnic minorities in America, there is a fear among the older generation that the identity of the group is being jeopardized by the pressure of Anglo-dominated culture, and that the young people are losing their heritage and language. This is certainly true in some cases, but the Romani-American minority is not likely to disappear, and children brought up speaking Romani are still the rule rather than the exception—a good sign since loss of the ethnic mother tongue is the first indication of assimilation into mainstream society. The latest influx of Romani immigrants has also brought with it new ideas about ethnic awareness not generally characteristic of the much more conservative American Romani. There are now young Romani attending universities, and an all-Romani bulletin board on the Internet called *Drakhin* (which means "grapevine").

Given the tremendous odds that have faced Gypsies since their exodus from India one thousand years ago, it is a remarkable tribute to their endurance as a people that the Romani thrive today, with a language and culture that continue to flourish. Survival over the centuries has been ensured by maintaining harmony both inside and outside—by preserving the internal values of community and tradition while adapting to the changing demands of society at large.

THE LIFE OF THE SOUL

BY REBECCA BUSSELLE

PHOTOGRAPHS BY CORNELIUS M. PIETZNER AND STEPHAN RASCH

Camphill is an expression of a great intuitive thrust out of the deep heart of nature which has us in its keeping, and knows that both we and it are in mortal peril. —Sir Laurens van der Post

Dusk, early winter. Karen, a woman with straight gray hair and serious glasses, sits at a table made of maple in a spacious and cheerful kitchen, a basket of wool at her feet. Around her, several people chat, while a woman reaches into a cupboard for mugs and tea bags. From the living room come the crisp notes of Bach, played on a grand piano. Down the hall, Susan sits on her bed gazing through a window framed by curtains of soft, gray silk from India.

Look again, more closely. Karen works yarn around the needles, adding crimson to a lengthy muffler already resplendent with yellow, lavender, green, and she holds the needles awkwardly. The woman who pours water from the kettle into mugs is a house-

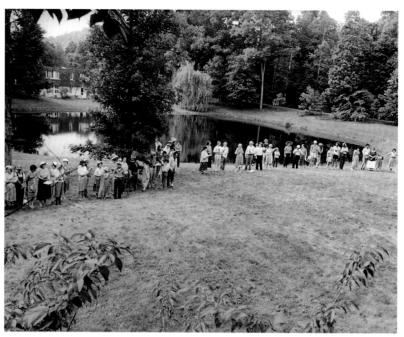

Cornelius M. Pietzner, from the "Village Life" series.

(The New York State system, perhaps reflecting a conservative ideology that evaluates human services in financial terms, currently designates people with developmental disabilities "consumers.") At Camphill Copake they are simply called *villagers*.

Home to over 225 people, Copake, New York is one of more than eighty-five Camphill communities worldwide, with seven in North America, several in Africa and Eastern Europe, and the rest in the British Isles, Western Europe, and Scandinavia. Each community operates autonomously but shares the principles of Rudolf Steiner, an Austrian visionary and educator whose concepts developed into the Anthroposophical Society, "an association of people who

parent. Her husband plays the grand piano, which dominates a room with Persian rugs, a spinning wheel, a card table strewn with a two-thousand-piece jigsaw puzzle. In the bedroom—one of ten in the house—Susan lifts her face in order to look out the window, her immovable eyes able only to see straight ahead, as though peering through a tiny hole. She parks her wheelchair beside the bed.

In this tranquil and gracious house on 680 acres of woods and farmland in the foothills of the Berkshires, just over half this extended family has developmental disabilities—a term that some call politically correct and others call an attempt to outdistance the stalking pejorative of labels. Twenty-five years ago, they would have been classified as mentally retarded, lumping together individual handicaps of cerebral palsy, epilepsy, neurological impairment, or autism; earlier, they were called morons, and worse.

would foster the life of the soul, both in the individual and in human society, on the basis of a true knowledge of the spiritual world." From anthroposophy grew, among other things, the Waldorf Schools, biodynamic agriculture, anthroposophically extended medicine, and numerous contributions in the arts and architecture. The name of the movement, Camphill, derives from the estate near Aberdeen, Scotland, where, in 1939, a group of Steiner students who had fled Nazi Germany, formed a community with a social purpose in a time of deepening chaos. Under the leadership of Dr. Karl König, a distinguished Viennese pediatrician, and joined by volunteers from Great Britain and central Europe, the pioneering efforts of this founding group set the example for sharing lives while honoring individual difference that defines the Camphill experience.

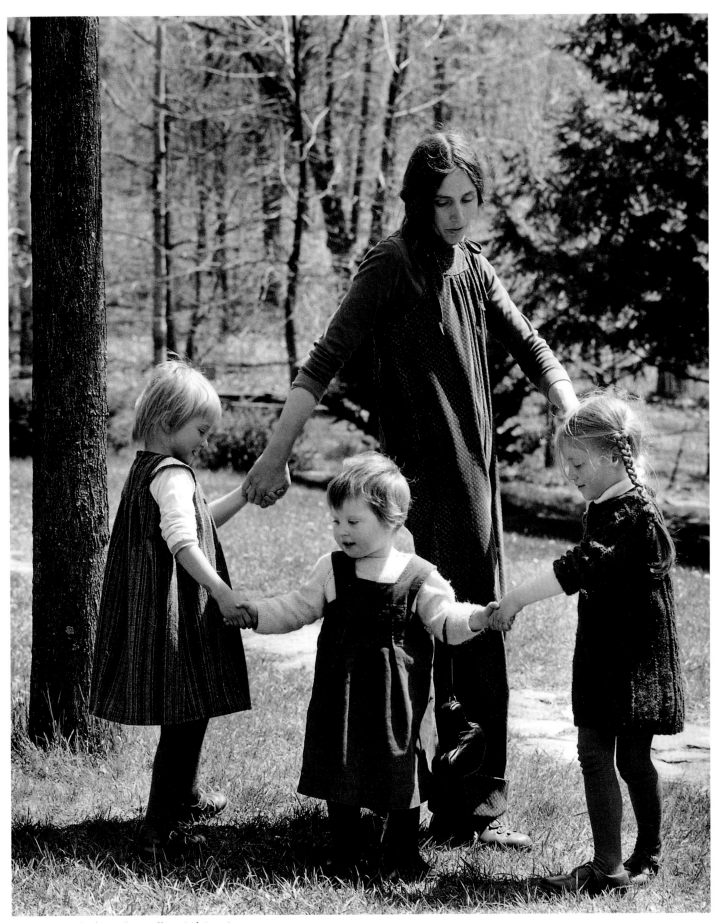

Stephan Rasch, from the "Village Life" series.

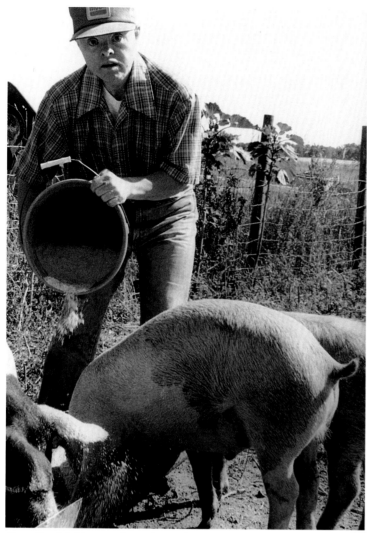
Cornelius M. Pietzner, from the "Village Life" series.

itual dialogue with a diverse community through which they invariably receive more than they give. They acknowledge the constant opportunity for renewal, self-examination, and expansion of human awareness. They rejoice in the special qualities of villagers, with whom they celebrate festivals and the changing seasons, sing Bach cantatas, produce plays and pageants, have barbecues, and laugh. Breaking barriers between the able and the disabled, the helpers and the helped, creates a therapeutic community in which healing works both ways.

Each community matches the needs of the collective with the talents of coworkers, who may teach classes, tend orchards and farm animals, work in kitchens, offices, and craft shops, administrate, and raise the ever-necessary funds. Camphill describes itself as a way of life, not a job. Status is not derived from work hierarchy. Coworkers labor without salaries, trusting the community not only to meet their basic physical requirements, but to identify and fulfill individual emotional and aesthetic needs. A community may see that one coworker needs relief from a long winter and provide a few days away, or that another needs a warmer jacket. Most longterm coworkers are married; many have families, and some have lived within the Camphill network the better part of a lifetime.

"My father couldn't understand why I wanted to dedicate myself to Camphill," a longtime coworker says. "He thought I'd cut myself off from life." For her, however, the decision was clear: she wanted a community where daily encounters forged deep connections rather than superficial ones. Cherishing people rather than material goods or the present-day glut of information, coworkers choose a life away from the mainstream, structured and in many ways protected.

Choice, by necessity, often means rejection. Most communities do not have television, although—perhaps reflecting the constant struggle to stay simple and focused while not falling terminally behind contemporary society—at Copake the desirability of life with a VCR causes much discussion. In another Camphill community a houseparent admits to a television in the basement and occasional stolen moments watching a Knicks game. "There is no utopia," one coworker says. "Community life is hard work, mentally and physically."

In keeping with Steiner's principles, villagers—or companions, as they are known in some communities—live in Camphill not only to benefit from such advantages as an excellent, fresh diet, curative therapies, music, eurythmic body movement, academic learning and a strong spiritual life, but also to strengthen and grow as contributing members of society. All have jobs. Each task is considered important, no matter how small. At Copake, where cows are milked twice a day, Charlie's job is to hold the cow's tail so it won't whack the milker in the face. Charlie has no replacement, and when he leaves the community for short visits home, he worries about the milker. Another villager shakes cream into butter, and has been doing so with a sense of pride for a dozen years. Some make candles, some weave, some work in the wood shop, bake bread, make cheese, or bind books. Valuing the land for its intrinsic beauty, as well as its resources, most communities

Camphill communities provide an innovative alternative to the bleakness of the institutional life that is still a reality for seventy thousand people with developmental disabilities in the United States, or to the often isolated existence in community residences within neighborhoods that are hostile or apathetic. In this house in Copake, the other occupants, called *coworkers*, are without discernible developmental disabilities and have volunteered to participate in a community that provides concrete ways to examine consciousness, aesthetics, and spiritual values within a structure of cooperative work and social responsibility. Camphill sees itself as part of a subtle, growing, life-sharing movement in which groups of people gather to support vulnerable populations.

Through anthroposophy, the Camphill philosophy espouses the concept that every human has a perfectly formed spirit as well as an individual destiny. The physical and mental housing of that spirit varies, embodying a greater or lesser degree of ability, but all people need friendship, meaningful work, artistic expression, and worship to achieve dignity and freedom. Coworkers do not see themselves as service-oriented, but believe in a constant spir-

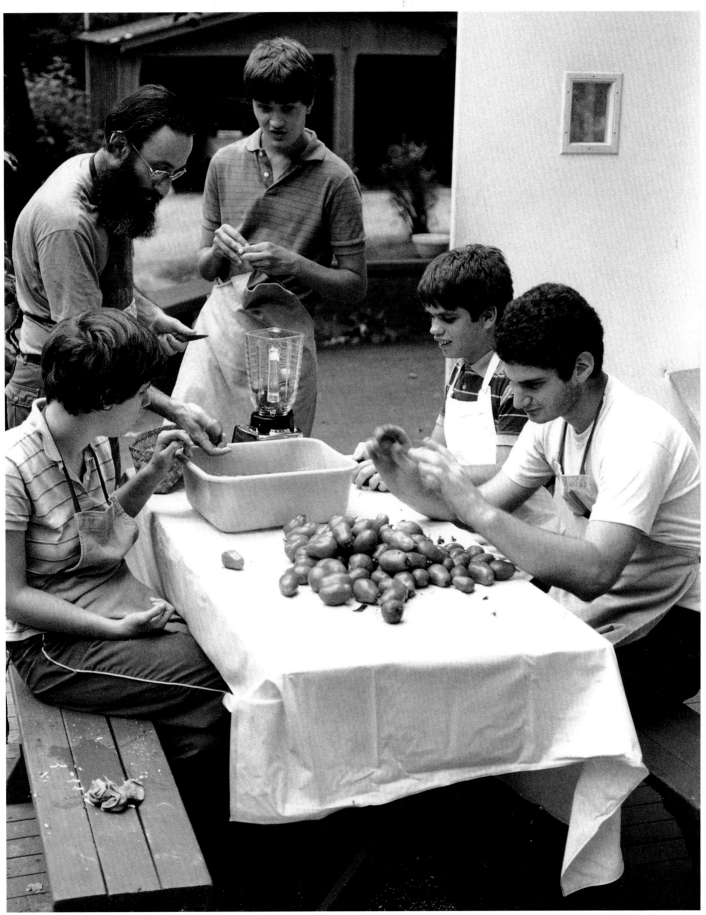

Cornelius M. Pietzner, from the "Village Life" series.

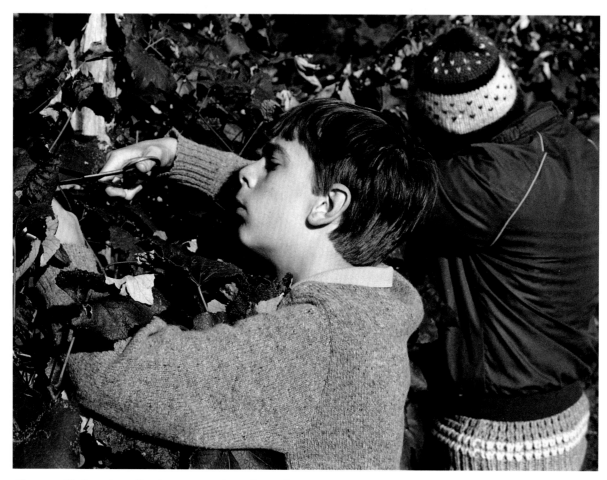

Above and below: Cornelius M. Pietzner, from the "Village Life" series.

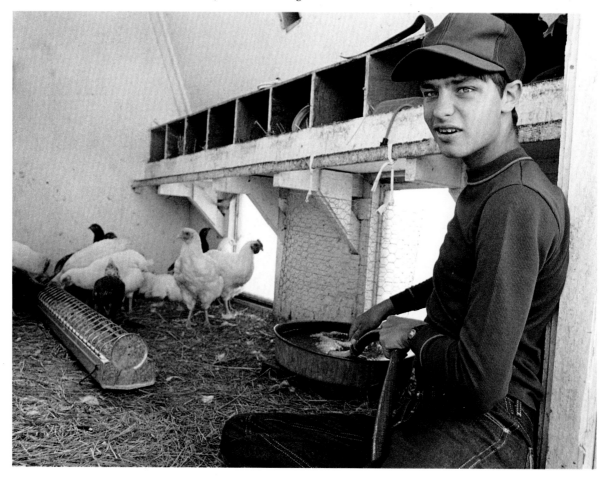

Stephan Rasch, from the "Village Life" series.

grow vegetables and herbs for consumption and sale, shear sheep to spin wool for weaving, and make and distribute excellent fruit spreads and jelly. Excerpts from the diary of a Copake villager, Edna, show a calm acknowledgment of natural cycles:

April 9: The estate took down the maple sap buckets.
April 16: George Chamberland died in the afternoon.
May 2: We had quite a storm and also a few trees fell.
May 14: It is nice to see all the cows and horses out in
 the pasture again.

While the emphasis is on an adapted form of Waldorf education at Beaver Run, a Pennsylvania village and school for children aged six to eighteen, here, too, Camphill incorporates the structure, obligations, and rewards of tasks. Coworkers report that villagers who come from Beaver Run to Copake, an adult community, have an easier time adapting to the concept of work than do those who have lived at home, where most have experienced a lower expectation of participation.

For villagers as well as coworkers, questions arise about leading a life some would call cloistered. Institutions for the mentally retarded—even when renamed as developmental centers or villages—at best hold little hope for stimulation from the outside world. At worst, institutions promise a life of abuse. Group homes operated by state or private agencies vary in quality, but in order that they not become mini-institutions, meaningful inclusion in the larger community must be a persistent focus, one which most house staffs have little incentive or energy to accomplish. Paid jobs are often the shining star of an integrated life for people with developmental disabilities, yet most of those jobs are barely paid, repetitive, and perceived as demeaning. How, then, do Camphill communities—which consciously strive to contain and mold their own environments, remaining as self-sufficient as possible—keep from qualifying as elitist mini-institutions? And is holding the cow's tail day after day the equivalent of shrink-wrapping books, or constantly fitting one mechanical part into another?

Part of the answer lies in the concept of *interdependence*—acknowledging frailty in all humans while undertaking an enduring search for the appreciation of human strength and beauty through mutual engagement. Due to their bureaucratic nature, institutions foster dependence, while promoting "independent living skills." The only sign of true interdependence is financial remuneration—

hardly the spiritual dialogue Camphill nourishes. However, Camphill is sensitive to criticism that it keeps villagers from the outside world. Each Camphill community assesses the needs and goals of applicants before they join; a visit of several weeks ensures that the life offered is the one desired. During the past decade, communities have recognized that some people, including long-term villagers, may require a larger context in which to thrive. Several have initiated special programs. At Camphill Soltane, a community for young adults on rolling farmland outside Philadelphia, some villagers hold apprenticeships and jobs in adjacent towns—in the hospital, the library, an automotive manufacturing plant—carefully tailored to the individual. These are not segregated, sheltered workshops, where people with disabilities are hidden away with their own kind, but thoughtfully designed situations, and, a coworker admits, "a transportation nightmare." Although abiding by the rule of consensus, not everyone in the community is convinced that this is the proper direction for Camphill. Another coworker warns: "A broader palate doesn't always bring greater happiness."

In Camphill communities happiness is visible, expressed through a palpable serenity that is molded by the forms and rhythms of a secure life. These photographs—taken by accomplished photographers who are coworkers in Copake and Soltane—are as direct and unaffected as the people they depict. Their purpose is clear: To give visual life and understanding to the intentions and realities of Camphill. They imply history as well. In them, some people look slightly anachronistic—as though they'd been imported from the first Camphill without aging: "The timelessness of being human," a coworker comments. The photographers pay quiet homage to their subjects, honoring the sense of mutual engagement and connectedness that sustains each community. In these photographs no one is objectified, set apart, or made grotesque.

Devoid of artifice, the pictures show a lyrical gathering on a summer

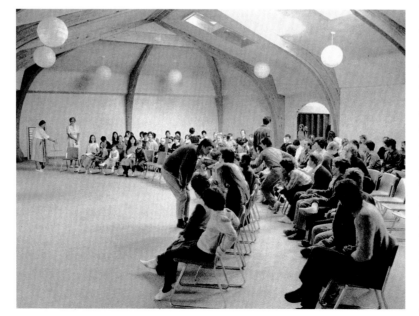

day; the quiet concentration of a boy snipping at grape vines; communion, joy, and responsibility as people care for animals and fellow humans. The photographs are incisive, the subjects distinctly individual, yet the cumulative effect is to blur the perceptible differentiation between the able and the disabled. A couple ascends a wooden step, the woman slightly ahead, helping, patiently guiding the man whose hand she holds. Is she a villager or coworker? In another photograph a woman makes a circle with three children—her own? Disabled? To whom is it important?

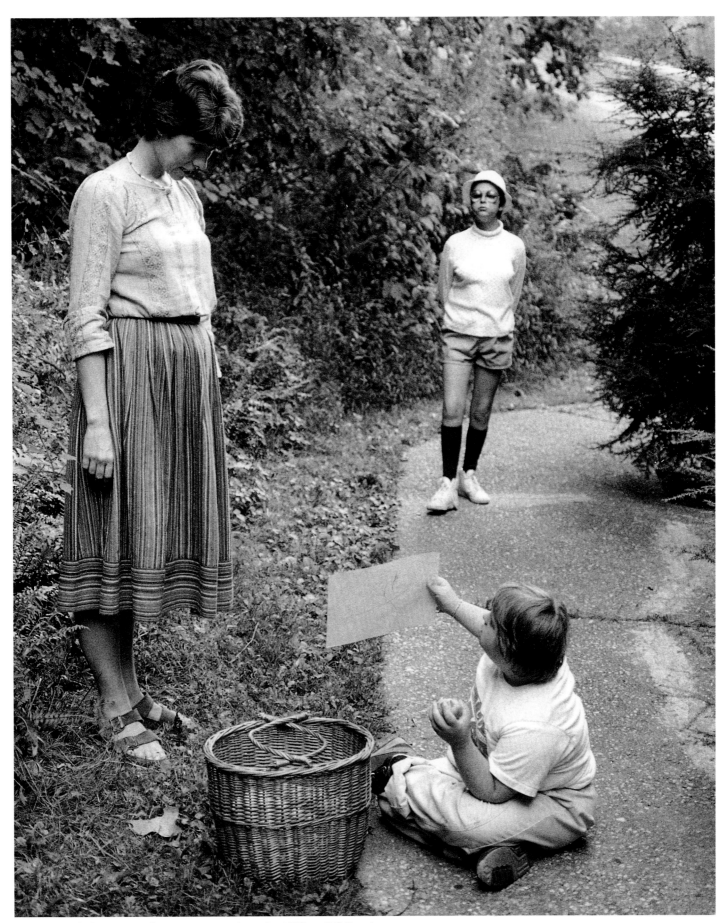

Opposite and above: Cornelius M. Pietzner, from the "Village Life" series.

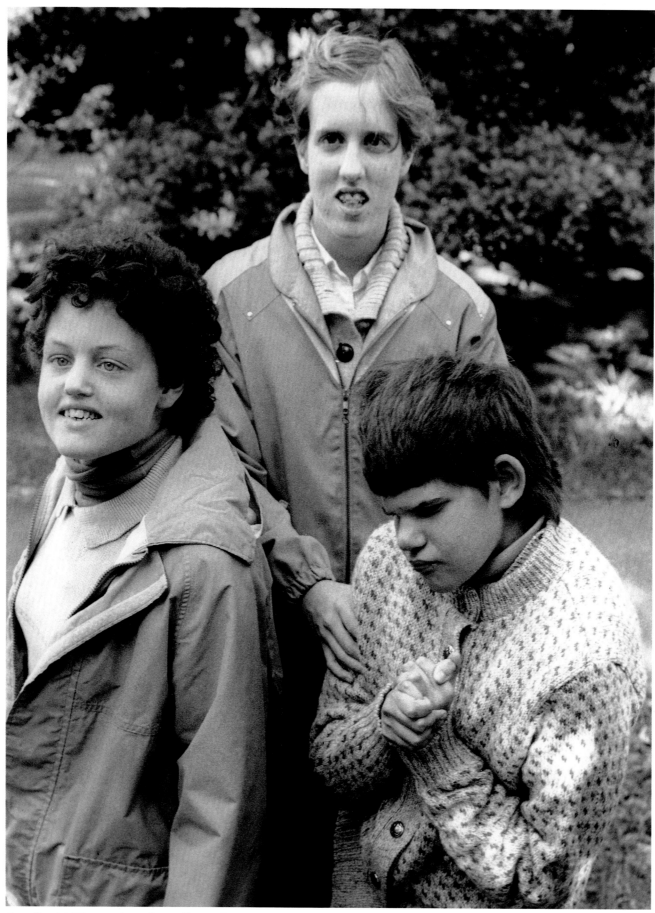

Cornelius M. Pietzner, from the "Village Life" series.

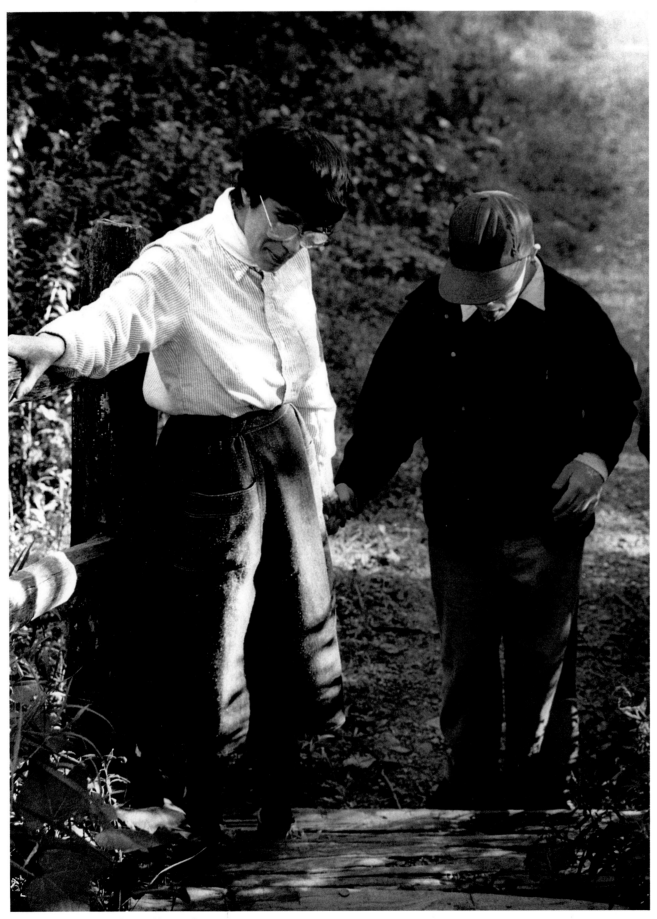

Stephan Rasch, from the "Village Life" series.

BUSHVILLE

PHOTOGRAPHS AND TEXT BY MARGARET MORTON

In 1987, three homeless men who had been living in Tompkins Square Park cleared debris from a city-owned vacant lot on New York's Lower East Side and built simple plywood dwellings for themselves. Other homeless people joined them as they scavenged for materials in the early morning hours and assembled the makeshift structures. Eventually, fourteen small houses were clustered along a central path, forming a village that provided not only a sense of security, but also a sense of community.

The residents were all of Puerto Rican descent, and the houses, which were continually under construction, bore a closer resemblance to the architecture of their builders' homeland with each addition. Brightly painted *casitas* flew the Puerto Rican flag; intricately detailed open porches, gaily striped awnings, and painted rock gardens provided sharp contrast to the neighborhood's grim tenement buildings. Wooden pallets, plywood ramps, and carpets defined front yards; chairs and porches gave individual character to semiprivate spaces that flanked the main walkway. Neighbors from the nearby projects, most of whom were also Puerto Rican, used the path as a convenient shortcut through the block and would pause to converse in Spanish with the residents of what they called "little Puerto Rico." A scavenged sign reading "Bushville," which Hector Amezquita nailed onto his house, gave a name and, according to Hector, a feeling of respect to this little village.

Mario Gomez, who came to the lot in 1989, was assisted in building his house by a friend who needed a safe place to store his frankfurter cart. Mario did odd jobs for other Bushville neighbors, including transporting water from the nearby fire hydrant to Pepe Otero for three dollars a week. Trained in electronics, Pepe added a tool room onto his eight-by-eight-foot plywood shanty and repaired radios and televisions for people in nearby tenements. His repair business expanded after one of his friends in the apartments supplied him with electricity through an underground cable for forty dollars a month. Another neighbor paid him twenty dollars to build a wooden cross to mark the grave of her son. Pepe added a bedroom, kitchen, and music room onto his house, and the plywood shack he had originally taken over from another homeless man eventually became a five-room home.

Juan Guzman, one of the first Bushville residents, used the exterior wall of an abandoned tenement building as the fourth wall of his house. He added a fence of pallets to contain the chickens and rabbits he fed for apartment dwellers who missed the rural ways of their villages in Puerto Rico. In November 1991, after an illness, Juan died in his home. Gumercindo Ortega, who lived in a nearby apartment, bought the house from Juan's widow for forty dollars, and then rented it to R. Duke and Tanya Lopez for that same amount per month. Tanya was four months pregnant, and Duke was anxious to find more substantial accommodations than their tent beneath a ramp of the FDR Drive.

Gumercindo Ortega, who became known as the "Godfather" after he bought and rented another house that had been vacated, built a house next to Juan's, which he used as a weekend cottage. He would arrive at the lot, his dog on his arm, set up table and chairs, and preside over a succession of domino games. Sometimes he would bring his *guiro*, a percussion instrument scratched with wires, and residents would emerge from their tiny houses with maracas to play Puerto Rican folk music and dance with neighbors from the cramped tenements.

Another frequent visitor constructed a chain-link fence along the main path and planted green beans, which provided a source of food for the community. Eventually, Pepe built a private garden, walled with orange plastic bread trays from the nearby market and linked to his house by a *marquesina*, or roofed walkway. He shared his pumpkins, which were boiled for food, but his tomatoes were destroyed by vandals. A butcher on Avenue C regularly donated poultry to the community, and Mario cooked it over an open fire.

Other neighbors did not empathize with the plight of Bushville residents, however, particularly newcomers overlooking the lot from recently renovated tenements. They convinced local police that the people should be evicted and the lot transformed into a community garden. On December 15, 1993, in the early morning hours, Bushville was demolished by city sanitation department bulldozers. The residents were notified of the impending destruction, but because they had been offered no acceptable alternatives, few heeded the warnings. They were left with only a few moments to salvage their belongings before the bulldozers arrived.

The noise of the heavy equipment was deafening as the tenderly constructed houses were wrenched from their foundations by massive shovels, held high, then hurled to the ground. The residents scattered, seeking temporary shelter in doorways, abandoned cars, or with friends as their fragile illusions of home fell into splintered piles of refuse once again.

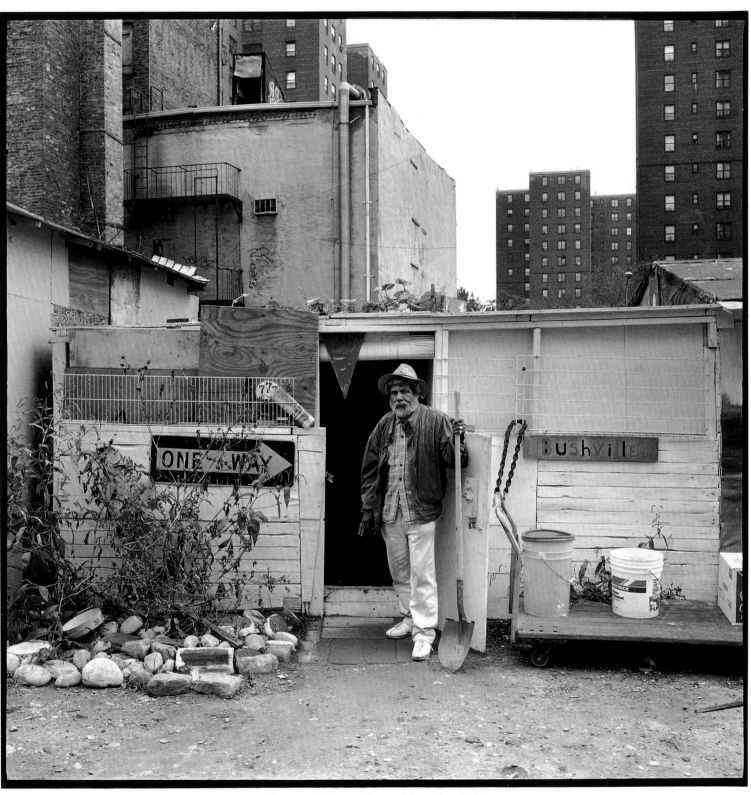

Margaret Morton, *Hector*, November, 1991

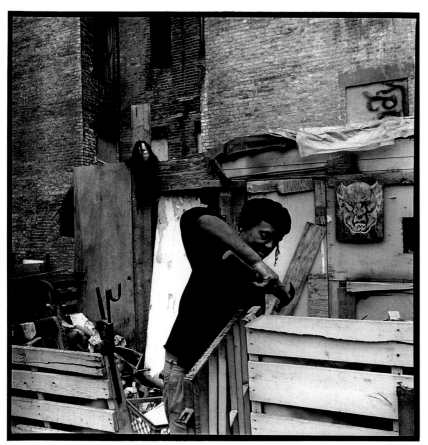

Above: Margaret Morton, *R. Duke Repairing Fence*, 1993
Below: Margaret Morton, *Yvette and Monin's House*, 1991

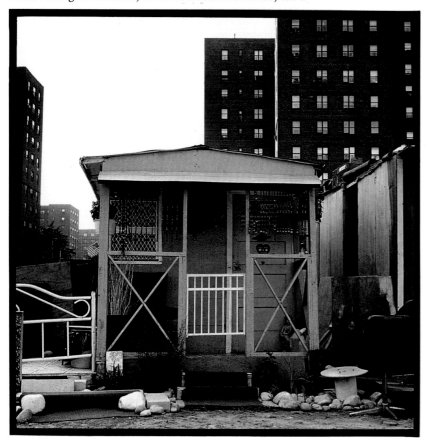

HECTOR

Before me, this place was garbage, you know. There was nothing here. I built this house myself. I started it. I carry all these things myself over here, from the street, from everywhere, found them on Eighth Avenue, First Avenue, every piece of wood, I found it. Little by little, little by everything. I carried it all—for more than two years. • The first time that I move over here, I start like a poor person. Now I feel better, now I feel comfortable. Nobody bother me. I have to do it, because I'm an old man already. I'm on to fifty-five, too much for me, for me it's like a hundred. • This is my work. I can't work here, I can't work there. This is something I've got to do with my life. I figure if I don't do something here, my mind will die. I am my own boss and I know what I have to do, what I need, what I don't need. I don't call nobody to help me.

DUKE

I grew up in the southern part of the United States; North Carolina. I like this because it's not like a New York atmosphere. It's like a little village inside of New York. The people here are Puerto Rican and come from that rural country life. They like this feeling. If they move into this city housing, it won't feel like this. • When we first moved in here a guy had died in here, you knew the guy. He stayed in here three days. Well, we seen this guy in here a couple times—his spirit. Tanya has. I have. After that we never blew the candles out at night. Tanya won't spend the night here alone. That's why the place is haunted. Because his spirit is restless. • I saw smoke coming out around the fringe of the door. And I can't let Mario's house burn up while he's gone. I smashed the door open and I'm trying to tear this board off the wall to get the fire out and as I'm putting the fire out I look and I see a hand laying off the bed and it was Mario's girl. I said, "Get out. It's on fire!" They jumped right up. Mario was in shock. Everytime she sees me she says, "Thanks Duke. If it wasn't for you, we would have probably died in there."

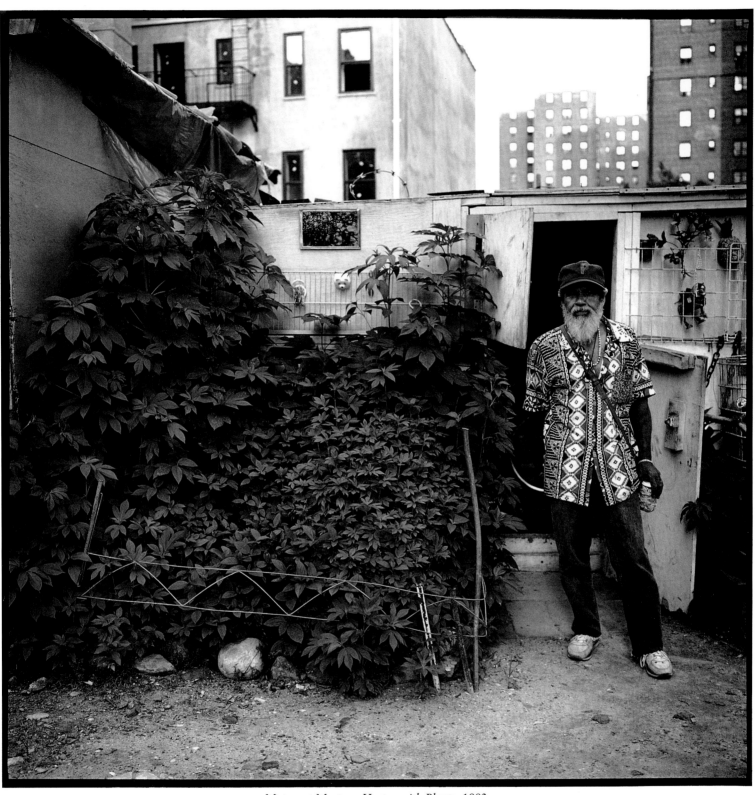

Margaret Morton, *Hector with Plants*, 1992

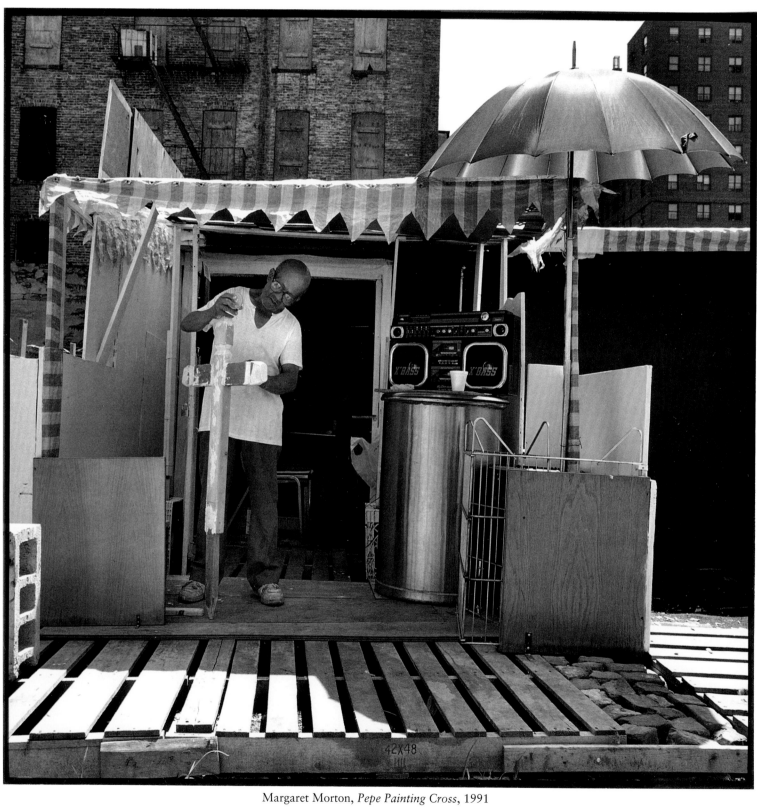

Margaret Morton, *Pepe Painting Cross*, 1991

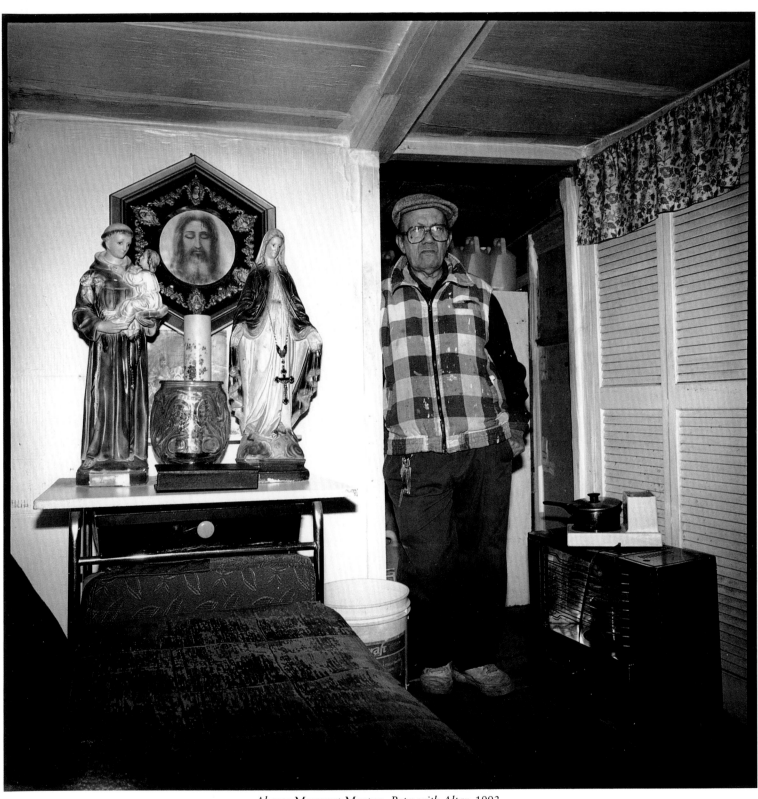

Above: Margaret Morton, *Pepe with Altar*, 1993
Pages 42–43: All images, Margaret Morton

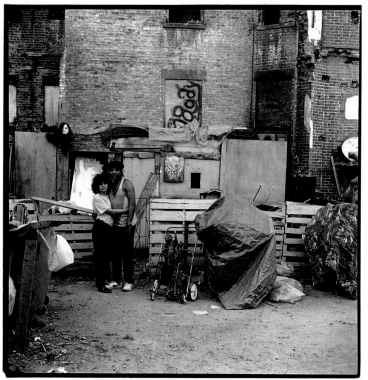

Tanya and Duke, 1993

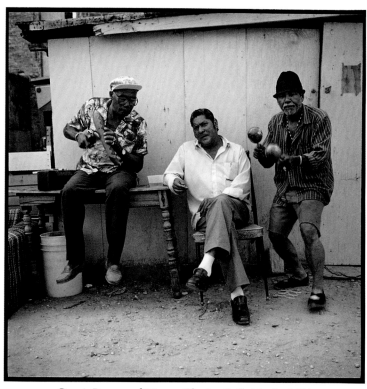

Gumi, Paco, and Hector Playing Folk Music, 1991

Neighbors from the nearby projects, most of whom were also Puerto Rican, used the path as a convenient shortcut through the block and would pause to converse in Spanish with the residents of what they

Gumercindo with Dog, 1991

Pepe Gardening, 1993

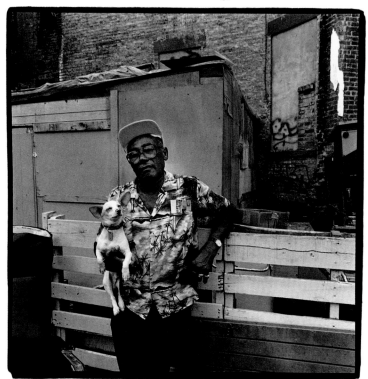

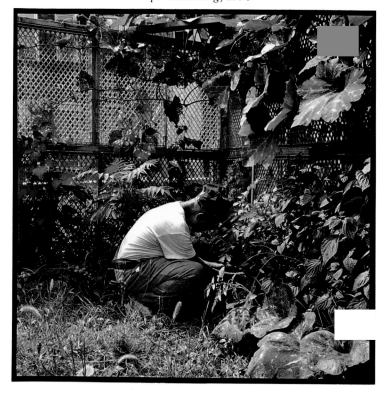

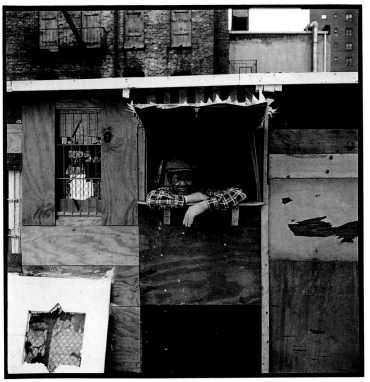

Pepe in Window, 1991

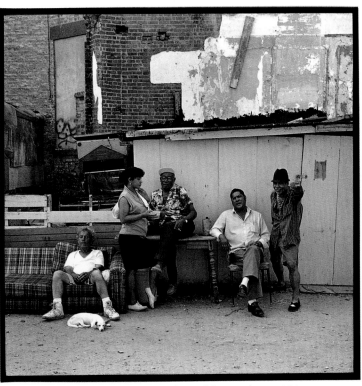

Bushville Residents and Neighbors, July 4, 1991

called "little Puerto Rico." A scavenged sign reading "Bushville," which Hector Amezquita nailed onto his house, gave a name and, according to Hector, a feeling of respect to this little village.

Juan with Rabbits, 1991

Mario Cooking, Bushville Neighbor, 1993

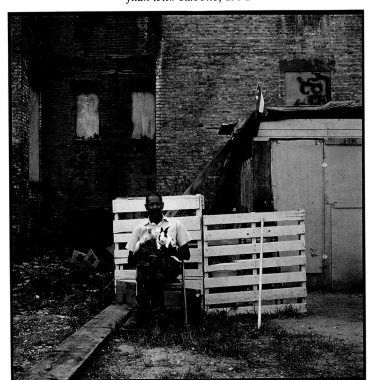

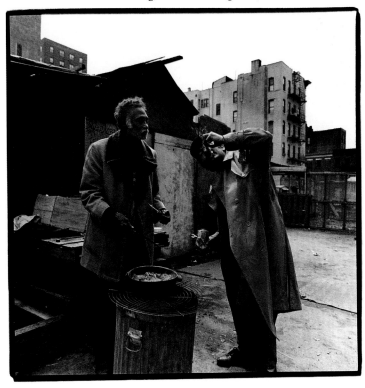

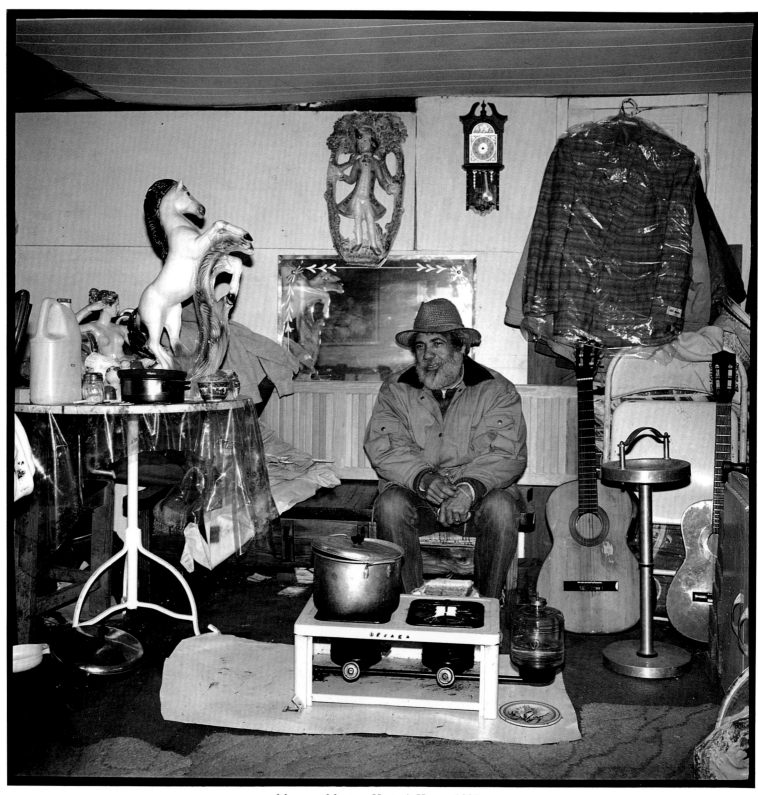

Margaret Morton, *Hector's House*, 1991

PEPE

Otero means "watchman." That's what I am. I watch out for everybody here. • I'm no architect, God is the architect, he is the best, the best architect in town. This, when I took over, was nothing, nothing. I had so many leaks, leaking all over, and too low, I had to push it up two inches more. • I came to this country because somebody told me, "Oohh, you could make a lot of money in typesetting." I said, "Oh yeah? Then I'll go to New York." When I came to New York, I got a big, bad surprise, because in those times, the minimum salary was thirty-four dollars a week. I was making more money in Puerto Rico. • The kitchen is still unfinished, have to finish the kitchen. Then I going to start the bathroom, soon as the weather get a little warmer—if I still alive.

DUKE

The guy said, "Well, I'll rent it to you real cheap, you'll just have to work on it yourself," so I cleaned it out, worked on the roof, put the window in, and now I'm working on some heat. I was thinking about building a little fireplace. • I've been living here almost three years myself, and Pepe, he's been living here longer than that. And there's other people been living here longer than that, and it's sort of like a home. We don't have money to move up into these buildings. We don't have money to move anyplace. We've been staying here for three years, and it's like a home to us.

HECTOR

I figure this is my break-through to stay here, because I believe in God. But sooner or later—the city— they going to chop these houses down. I want to know, will they put something here for the people working hard? They suffer making the houses here. I would like to know if they are going to take care of those like me.

TANYA

Everywhere we go they wind up running us out and I have to start all over again. Duke always carried that little house he made from plastic. He carry that all the way from Sixth to Tenth Street, from Tenth Street to East River Park. That way I can sleep well.

DUKE

I don't know why they want to tear it down. I mean the place has a sort of a feel to it, because children come through here every-day. There's never ever been a problem with any kids getting hurt or anything. Kids come here, they run through here. Every afternoon they play out here.

There's never ever been a problem. • There aren't any more little homeless villages anywhere in New York City. This is the last one. I have my little home here. Now I find myself in the mornings about five or six o'clock listening for these trucks, because they said they're gonna bring bulldozers and dumpsters and back-end and front-end lifters, and they're gonna clear this place away. And I find myself listening for some bulldozer to come creeping off some truck. It's like some monster and I know I have to get out of the way. It's gonna eat me up and I'll move on. But I've adapted myself to all the places and things I've done, and I feel like after I got through the war in Vietnam, I can deal with all this stuff. Even though it bothers you, when they come with the bulldozers and all that, I'll walk down the street and I'll look back and say, okay, have it. I'm just going on to the next stage. You have to do that or you gonna go crazy with the bureaucracy stepping on you and people not caring about you. Hey, I built a pretty thick wall and you know, it's not gonna bother me. • Tanya was just saying last night, "They can't come without warning us, can they?" Yeah, I said, but we've been through that before. I try to get her ready, like hey don't worry about it. I've always had a place for her. I've made them all have a sort of home feeling, but this one had more.

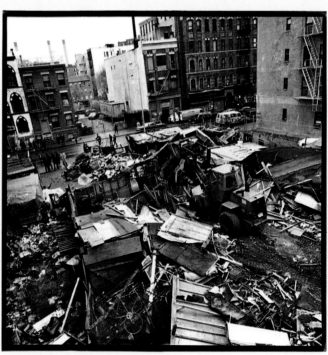

Margaret Morton, *Demolition of Pepe's Home*, 1993

THIS WORLD IS NOT MY HOME

PHOTOGRAPHS AND TEXT BY LARRY TOWELL

I met my first Mennonite immigrant in my father's auto-body repair shop in Ontario, Canada. David Reddekop wore plastic netting salvaged from a bag of oranges over his hair and his gums were bleeding. The night before, David had pulled out two of his badly infected teeth with a pair of pliers. His fourteen-year-old son, the eldest of ten children, had recently broken his arm; David shaped a cast from a cardboard box and wrapped it in masking tape. He was working for minimum wage sanding cars and sweeping the floor. At 5:00 P.M., he leaned the broom against the wall and drove off in his unlicensed and uninsured pickup truck.

In 1874, eight thousand Old Colony Mennonites left Russia to establish Canadian settlements in southern Manitoba and Saskatchewan. Less than fifty years later, nearly seven thousand of the most conservative members migrated from the Canadian prairies to newer reserves in northern and central Mexico. The attempted imposition of nationalism and state control of the school curriculum by Canadian authorities had forced another exodus of Mennonites. Migrating to a more receptive country, they felt, would preserve their communal and religious heritage. If they could not maintain separation of church and state and set themselves apart from secular society, they felt that their traditional group identity would dissolve. But that identity was to be challenged again on foreign soil.

In recent years, the inability of the Mexican colonies to sustain themselves in a limited space has created a landless peasantry. An uncompromising church that excommunicates those who work outside of the colonies, coupled with a collapsing Mexican economy, has forced many of the faithful out of the cloister and into the seasonal labor market of U.S. and Canadian vegetable farms. The hope of abundant tomato fields and regular wages prompts many to buy forbidden vans and pickup trucks for the five-day journey north.

In 1985, the Agricultural Employment Services in Kent County, Ontario, found jobs for eight Mennonite workers. In 1991 they placed 1,700. Ninety percent of Kent County's vegetable fields are now harvested by migrant and immigrant Mennonite families. Tens of thousands of Mexican Mennonites now work in the U.S. and Canada harvesting crops at far below minimum wage. Vulnerable Mennonite families are sometimes cheated by farmers who falsify crop grades (produce is graded at the canneries and payment is accorded by quality). As Canadian laws permit farmers to pay their workers after crops have been harvested and sold, some farmers withhold wages for months. Others do not pay unemployment insurance premiums, leaving families with no winter income—so welfare assistance is often their mainstay through the longest season of the year. Ninety percent of adults are illiterate and unemployable in anything but field labor and minimum-wage jobs. Most live scattered throughout the townships in run-down farmhouses rented from their agribusiness employers, and the distance families have to travel to meet together compounds a sense of alienation, which is largely imparted by old-fashioned ways. Men who founder in mainstream society often suffer feelings of personal failure that can lead to alcoholism and family abuse.

Adolescents who attend public schools are often ridiculed for their unconventional ways; many drop out before age sixteen. And the school calendar is inflexible for these children, who must help support the family during the planting and harvesting season. For mothers at home, social contact is limited to other Mennonite families. Separated by distance and lack of transportation, they languish alone. Most never learn English, attend a class, or develop outside friendships.

Mennonite migration from Mexico has now reached a watershed. Many families continue to live a transient life, journeying the highways between two worlds. They long for and romanticize the traditional society left behind. For those who struggle with God at the end of a hoe, the security of community, church, and land may be at least another generation away.

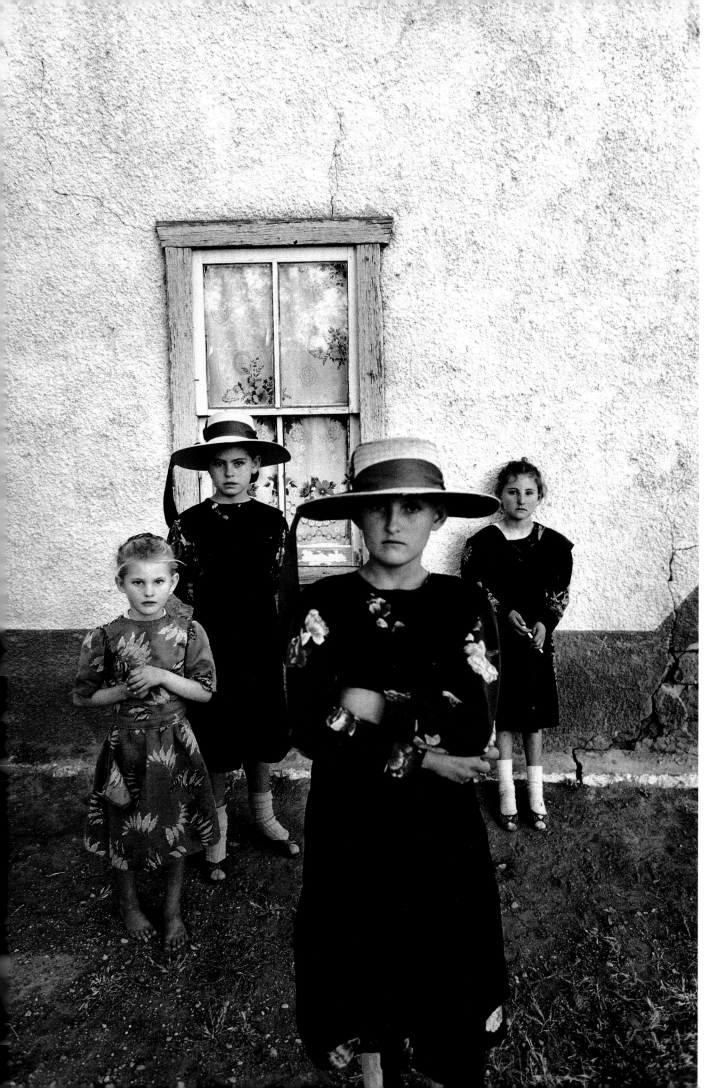

Larry Towell
Some of Bernardo Smyth's twelve children, Nuevo Ideal, Durango, 1994

Pages 48–49:
Larry Towell, *Ministers Praying into Hats*, Chihuahua, 1992

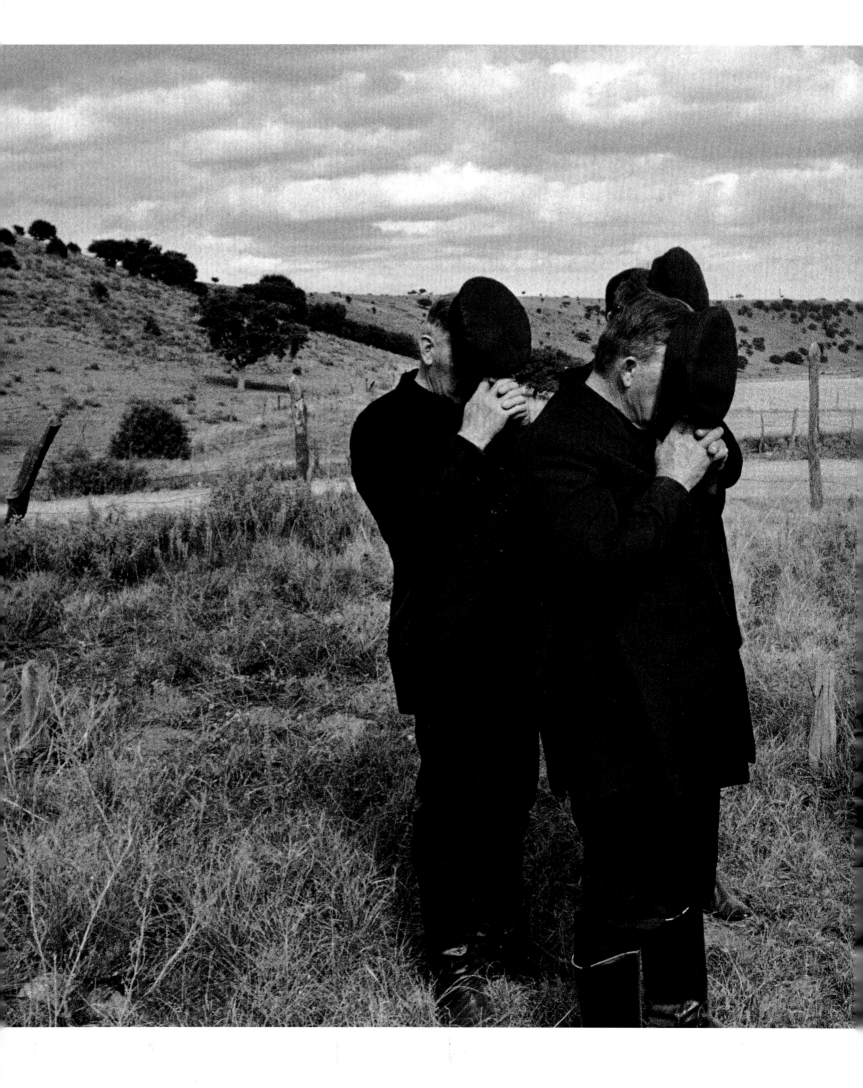

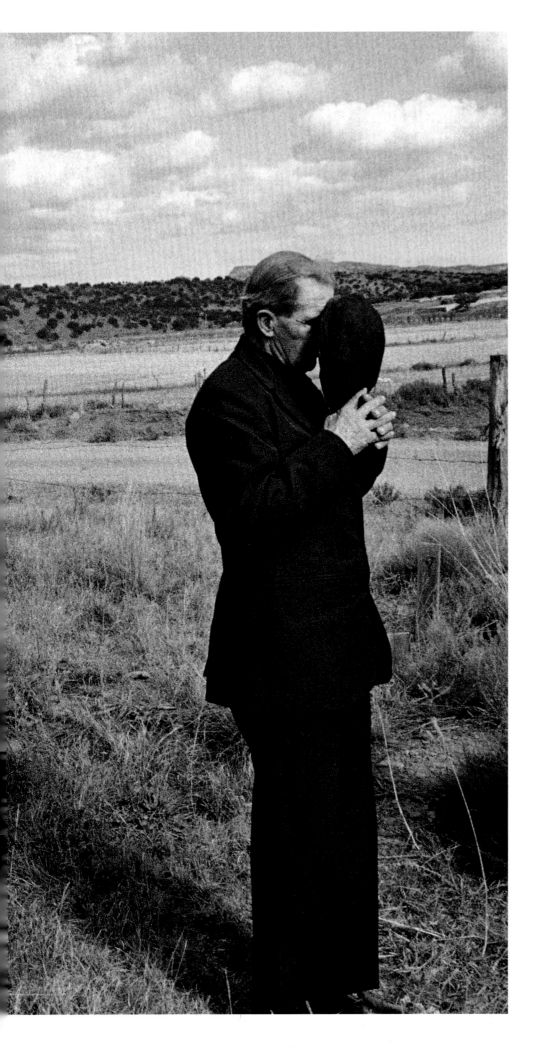

THE SUN SIFTS across the blood of a sow that was slaughtered this morning. Dust settles on the roofs of houses, covering them with a fine layer of sand. The sun cracks and burns, waiting for rain in a dry year. In the near darkness, dogs bark from barnyard to barnyard at the arrival of man into their yards, or just passing by.

Fathers are in the barns milking their cows with the women and children. For the third year, the men slave into the desert with their wagons at sunrise to harvest cactus for cattle fodder. For the third year in a row, a bale of hay costs more than half of a man's daily wage. The men in the barns fill their pails, straining the milk. It has the rank odor of digested cactus. The cactus flushes through the cattle like water and its needles often catch in the cows' stomachs and make them complain. You can hear cattle's bawl mix with dog's bark as children haul milk to the roadside. Cats dart like shadows among the girls pulling wagons of milk to the road. Although relieved of their milk, the cattle continue to bellow.

As I walk from the house where David Reddekop was born, the dust puffs up like talcum powder. The road is deeply rutted by wagon wheels and there is dried grass between the ruts. A wine bottle that Cornelius Klassen tossed aside this morning is coated already with a very fine layer of dust. The sun is almost gone now. A little wagon approaches almost furtively, with Herman Wall and his wife silhouetted inside of it. They are carting a forty-five-gallon drum to a communal windmill that pumps water for those without wells of their own. Herman has large ears and protruding teeth for which he was taunted as a boy. Now the same few schoolmates have become men and they harangue him still. Herman reins in his horse and leans toward me, whispering. I've never seen a Mennonite beg money for food. This is the first time.

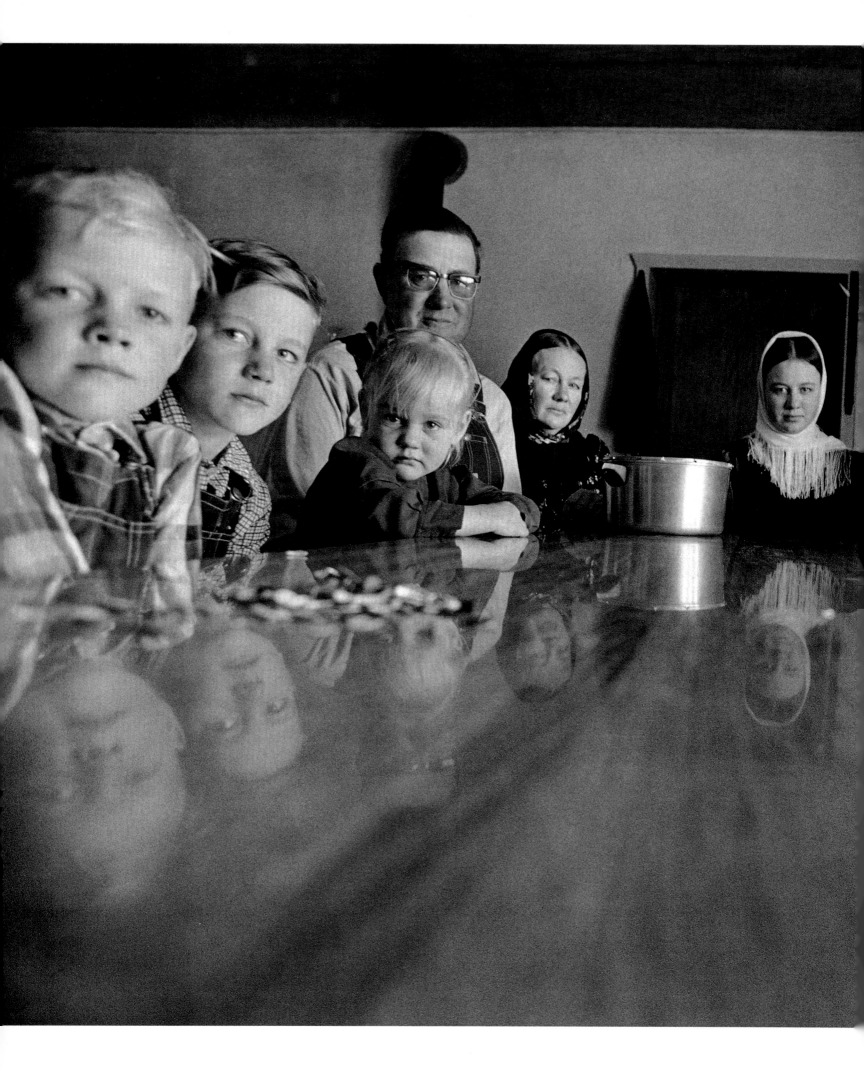

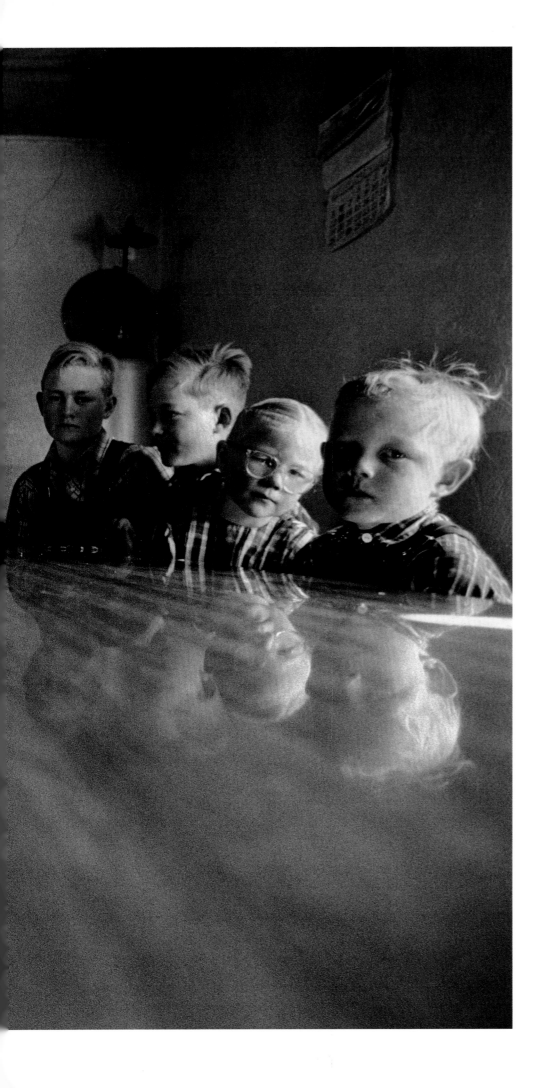

ABRAHAM AND HELEN Dyck's
house is set in the solitary desert.
Its kitchen is sparse but brightly
painted. From this room, their four-
teen children have scattered north-
ward to harvest vegetables and
fruit. Poverty and debt sink many
in Mexico.

The hot light from a Coleman
lamp, which is saved for special
occasions, illuminates the bible
Abraham reads. The lamp gives off
a liquid heat. The light is sharp
and much brighter than kerosene.
Although I cannot decipher German,
judging from Abraham's place
within the text I guess he is some-
where in the New Testament. He
has a pained look on his face and
seems unconscious of my presence
at the table. Maybe he is reading of
the crucifixion or has accepted some
chastisement in a personal way.
The lamp, clear and almost divine in
its heat, spills its new-coin brightness
all over the table.

Mounted in the ceiling is a six-volt
vehicle bulb salvaged from a car and
wired for battery operation. Abe's
head is bent low and his face has the
quality of light itself. He does not
use the bulb because, although it is
somewhat ingenious, the church
ministers have visited to remind him
of its implications of worldliness.
There are two voices. Satan loves his
soul as much and as dearly as the
Lord does.

Larry Towell, *Part of a Family of Fifteen
Children*, La Batea, Zacatecas, 1994

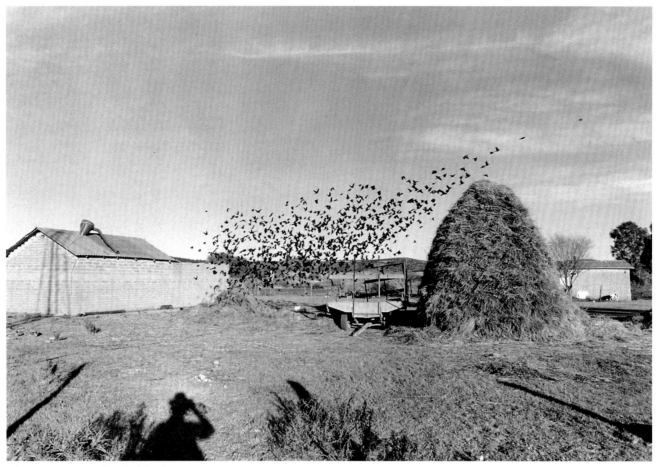

Above: Larry Towell, *Blackbirds,* La Batea, Zacatecas, 1994
Below: Larry Towell, *Isaac Welke with Wife and Son*, La Batea, Zacatecas, 1994

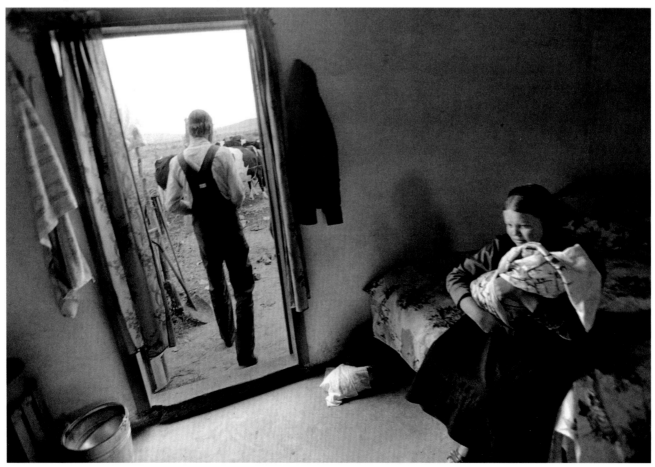

IN CORNELIUS DYCK'S BARNYARD *an early model Chevy, its wheels removed, sits with one door propped open, allowing his chickens in and out. Tin covers the windows. The back taillight is gone. Perhaps the sedan transported a family here before its conversion. The ministers are now at ease.*

For these Mennonites the internal combustion engine can exist only in the work-horse tractor. Most are two-cylinder John Deere "A"s: 1948 to 1952. All are steel-wheeled. Should a modern machine arrive on wheels of rubber, full of air and inner tubes, it must be stripped, humiliated like a prodigal child, for these are the devil's wheels and must be replaced with iron.

> This world is not my home
> I'm just passing through
> —*Traditional song*

IN ABE'S BARNYARD *a rusted John Deere "A". . .*

Abe has sliced the tires from an old car and sewn them with wire onto the front wheels of his tractor to help reduce bumps that the steel wheels transferred along the shaft into the steering wheel and through his hands shaking his whole body on the iron frame. There are no inner tubes, just thin and treadless strips of rubber. This combination of wire, rubber, and steel has caused some confusion in his barnyard and I have even noticed the chickens picking at the rubber when they pass by. The ministers have been unable to agree, and therefore do not pass judgment. They have left it to Mr. Abraham Dyck, father of fourteen, to wrestle with his angel at the kitchen table in the purest and hottest of light.

In the morning, he does not drive the tractor onto the road where it can be seen, but through the wire gate that was held closed all night by its binder-twine loop, straight into the bean field that is dry and forever thirsty
> *he drives his rubber over the blood of the sow.*

IN THE DISTANCE, HERMAN WALL *crawls like an insect into the desert,*
> *his buggy full of water, cactus, light,*
>> *and half a pig.*

Larry Towell, *Some of the Children of John Martens*, La Batea, Zacatecas, 1994

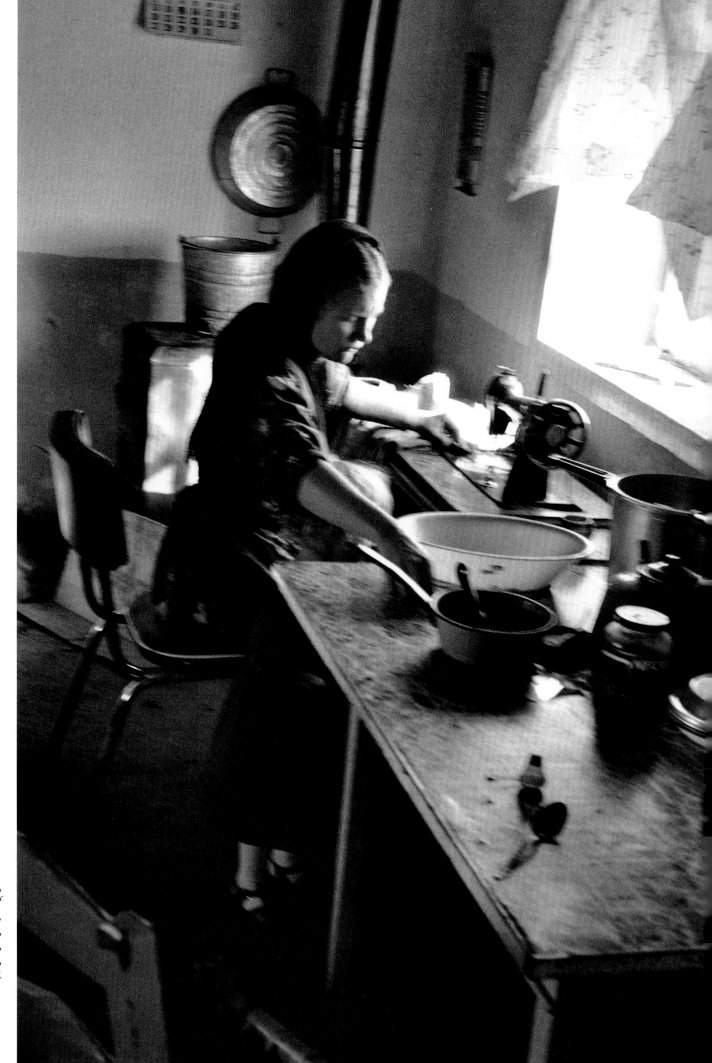

Larry Towell,
*Wife of
Jacob Dyck,
Sewing*,
La Batea,
Zacatecas,
1992

54

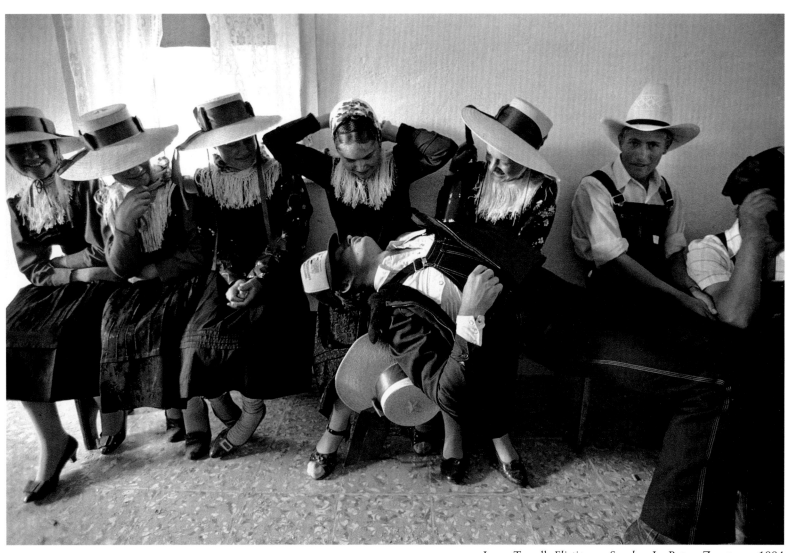

Larry Towell, *Flirting on Sunday*, La Batea, Zacatecas, 1994

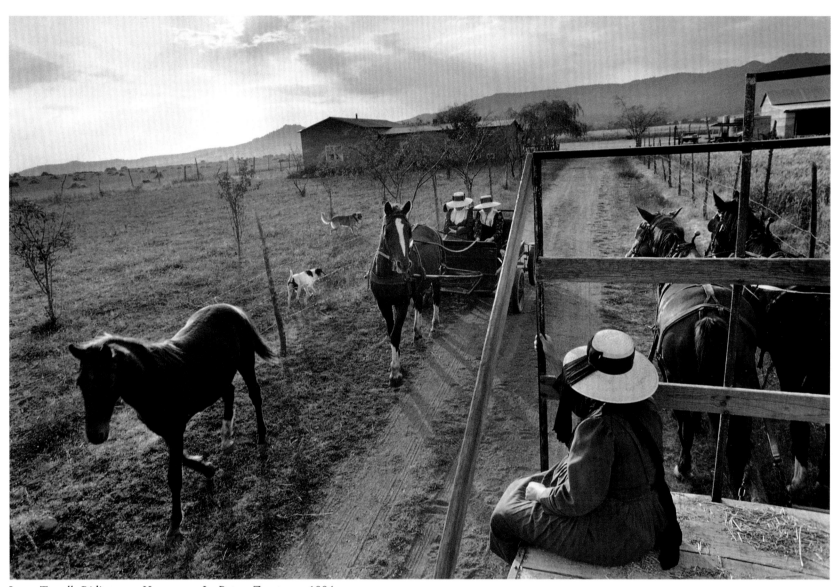

Larry Towell, *Riding on a Haywagon*, La Batea, Zacatecas, 1994

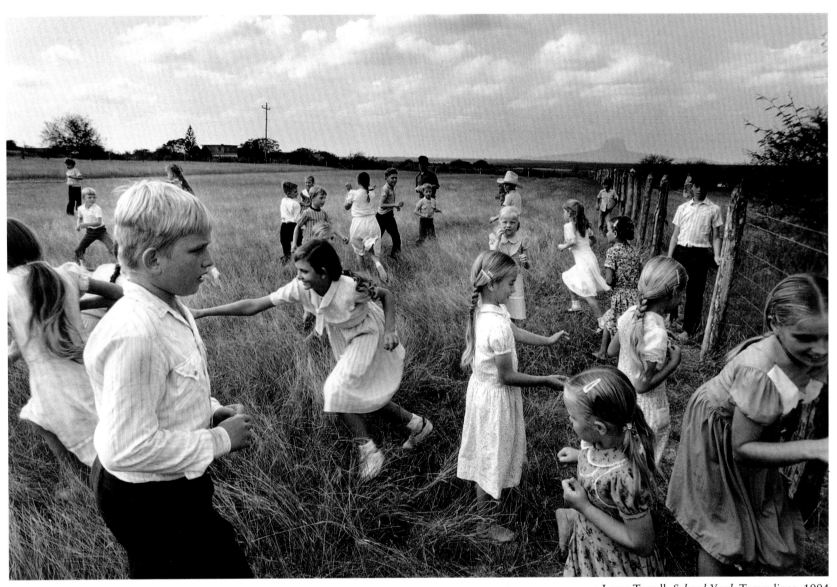

Larry Towell, *School Yard*, Tamaulipas, 1994

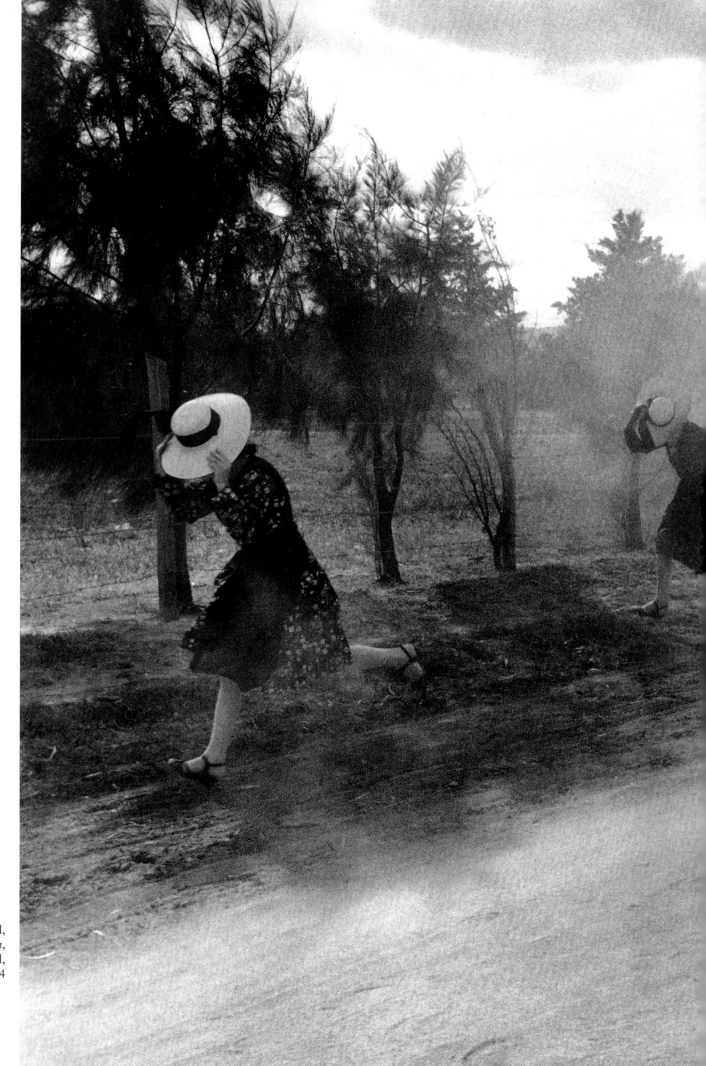

Larry Towell,
Dust Storm,
Nuevo Ideal,
Durango, 1994

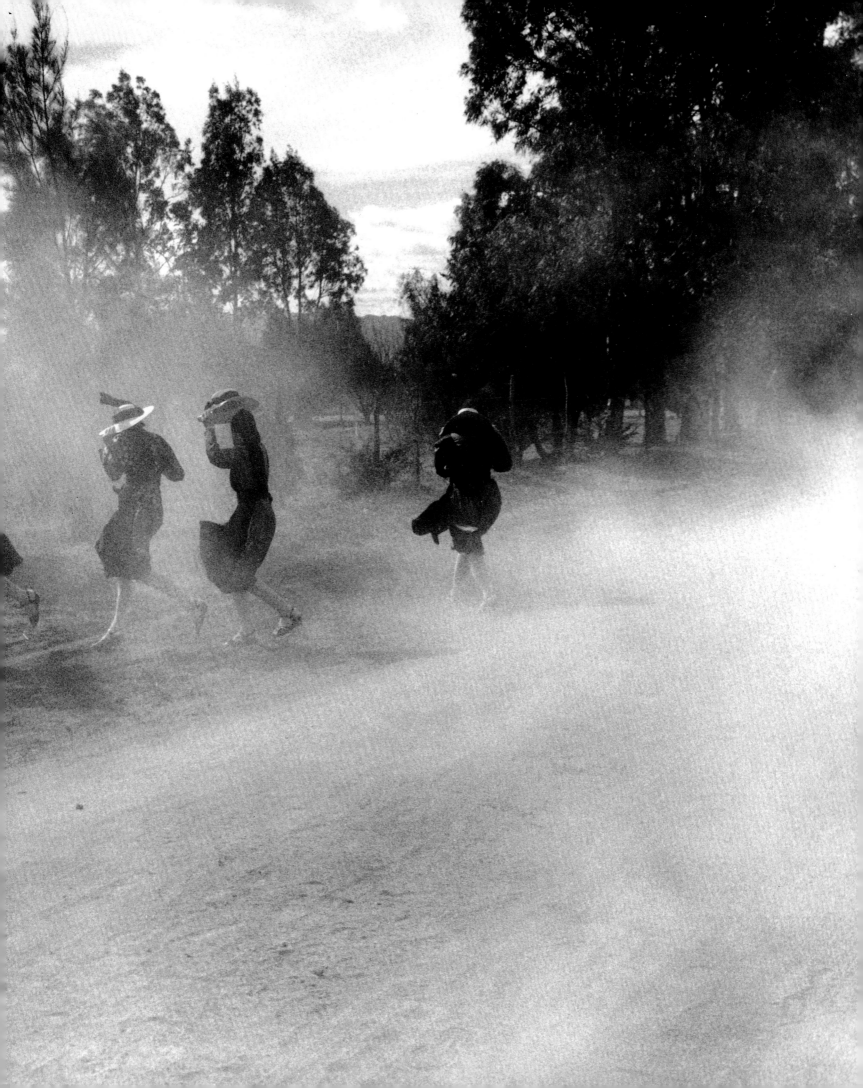

ALPHA FARM, DEADWOOD CREEK, OREGON

PHOTOGRAPHS BY EUGENE RICHARDS

TEXT BY JANINE ALTONGY

> Socially we're in a submarine. Whatever we achieve in terms of harmony and joy or tension and conflict, we will have to live with over a long period of time.

"Get your motor running, head out on the highway. Looking for adventure…," croaks Mike in discordant accompaniment to the old Steppenwolf anthem blaring from the door speakers of otherwise broken-down Baby Blue. With permanently blackened fingers, Mike goes over Blue's frozen pistons and valves and belts. It infuriates him to see the fine old car so neglected, so unused. He strokes the chromed fender and repeats his promise to make her as good as new.

"Born to be wild—born to be wild." Mike rolls his eyes and laughs. Born to be wild? Right! One year after turning forty, he abandoned his auto-body shop in Las Vegas to search for a more significant life—the family he didn't have, a community of sympathetic souls, any one of these things—and drove up the Oregon coast to Alpha Farm. He'd read a blurb in a handbook on intentional communities about how, in 1971, Caroline Estes, then forty-five, and her newspaperman husband, Jim, had this dream of creating a community to be governed by consensus, in which everyone would be social and economic equals. And here he is, out of the body shop and on Alpha farm, but still up to his shoulders in automotive grease.

"Mike, I'm making tortillas stuffed with melted cheddar, tomatoes, and sautéed slivers of onion," Veronica calls enticingly to him, interrupting his reverie. He hadn't noticed her trudging up from the main farmhouse in the awful, fuzzy, dun-colored bedroom slippers she always wears when it's her turn to vacuum the floors and scour the toilets.

"Sounds great," he lies, wondering if he could tempt her into the hayloft or to the recycling shed, where they could make love throughout what remains of the warm afternoon. But today's Thursday, a scheduled work day, and she's obedient to Matthew's schedule and anyway, he's got six more hours of his own jobs to go. But on second thought, it's worth a try. He smiles and nods his head in the direction of the shed, but down the hill she goes.

The day he arrived at Alpha in his state-of-the-art recreational vehicle, replete with TV, VCR, and a kayak on the roof, Mike was welcomed by each family member, eleven adults and four youngsters. Then his name was chalked onto a food-splattered blackboard in Alpha's kitchen under the column labeled "Extended Visitors." A day later, he wanted this to be his permanent home, and in the weeks that followed, he happily performed the daily tasks—splitting firewood, cooking vegetarian meals, canning fruit, and washing thousands of breakfast, lunch, and dinner dishes in what seemed like lakes of lukewarm dishwater. It was only after the evening meal's plates were cleared that his doubts would surface. A lively storyteller, he would stay up past 9 P.M. wanting to talk, but everyone else, it seemed, was exhausted by the day's labors, or locked into their own rituals, or somehow too defensive about the lives they had chosen to talk about them. They would slip away to their rooms. The kind of intimate, soul-searching relationships he so desperately craved after years of living in mean-spirited Vegas were not to be had at Alpha, either.

Veronica was something else. Having arrived at the farm only two weeks before Mike, she had half-hitchhiked, half-cycled clear across the country. She was gabby, idealistic, a touch macho, and for a twenty-four-year-old, Mike thought, more than a little naive. Mike couldn't believe that she'd buy a huge black Harley Davison so heavy with mechanical brawn that she couldn't brake it to a stop without falling over. She had bought it, she told him, picturing in her mind how cool she would look driving on an open highway. Mike told her that was pretty dumb; then again, he did like women who loved motorcycles and moving fast.

Veronica had also come to Alpha to experience what she believed communal life could be. She wanted to be free to have more than one lover; wanted to share her thoughts with people of all ages; wanted to watch the moon at midnight and ride horses at dawn; wanted to sit out in the pasture and let the fog that rolled in every day smother her past fears, until they were extinguished like the tiniest, most distant stars.

Almost as soon as she arrived, Veronica had been drawn to Matthew, Alpha's lean, muscular, sometimes dictatorial senior member, who was Lauren's partner. Long, sweaty, oddly romantic days spent refitting the barn and splitting logs had brought Matthew and Veronica together. Even Mike, when he first arrived, couldn't help noticing them whispering at dinner, in the hallways, and huddled up in Baby Blue, oblivious to the others.

Everyone at Alpha notices. Even Lauren, who continues to go about her business, seemingly unfazed, delivering mail every morning; serving meals at Alpha-Bit, the farm's bookstore/café in town; milking the two cows; and caring for the three small farm chil-

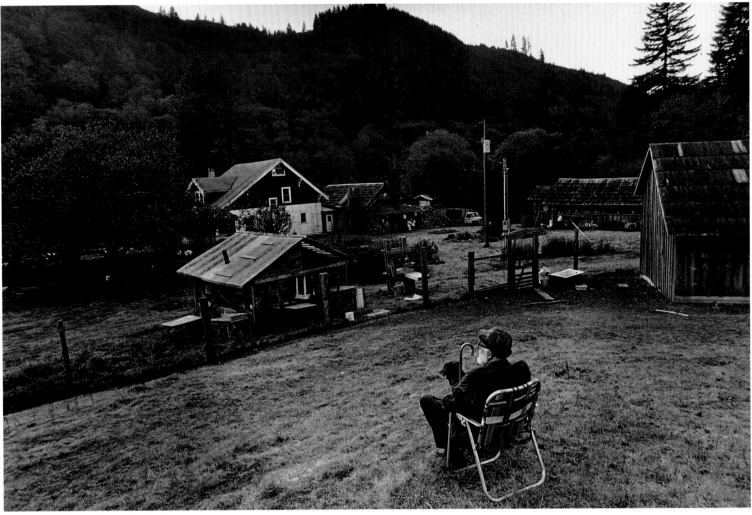

Eugene Richards, *Mac*, 1991

dren, including Derek, her own two-year-old son by Matthew. So Lauren knows. Everyone knows. It's hard to keep a relationship hidden at Alpha Farm. Lief, the farm's forty-five-year-old, long-haired self-styled philosopher, says, "Socially we're in a subma-rine. Whatever we achieve in terms of harmony and joy or tension and conflict, we will have to live with over a long period of time."

A pebble thrown by a child bounces off Baby Blue. Down the knoll from Mike, Nox gently and patiently instructs three restless little boys in the art of converting a garbage heap into a fruit orchard. Boyish-looking Nox, who seems wiser than his twenty-six years, fills the children's heads with images of what is to come: apple and pear trees bending under the weight of ripe fruit. "Pick up all the big stones you can find and don't throw them. Put them into this bucket," Nox repeats cheerfully for at least the tenth time.

Sam and Dylan are outfitted in tiny work gloves and dusty black field boots. Derek is naked, as usual.

"Look at this 'normous rock," Dylan pronounces.

"My rock is even more 'normous," Sam boasts. "Come and see." Then Derek begins to cry because the other boys, who are a full year and a half older than he, won't let him carry the bucket of stones down the hill.

At seventy-two, Lief's stepmother, May, is the oldest member of Alpha Farm. Hearing the sounds of the children, she invites her husband, Mac, to sit up in his bed and take a peek. Surely watch-ing the boys play will cheer her aged husband, who is sick with emphysema. But Mac does not respond. He doesn't glance up from a sheaf of papers he's reading, the ones from the Hemlock Society that describe the many ways in which a man can, if he wishes, take his own life.

It was in October 1991 that I visited Alpha Farm with Eugene and our son Sam who was then four-years-old. We were deeply affected by the experience and even considered a trial membership. Barely two weeks after we left, life dramatically changed at Alpha. Veronica drove away with Mike, she on her Harley, he in his RV. Then May died suddenly, casting poor Mac into a deep depression that hastened his death. Lauren eventually chose to leave the farm, as did Nox, with his wife Lisa and their two small children. Matthew and Derek later rejoined Lauren, who had settled not far from Alpha Farm, and the couple renewed their commitments.

In August 1993, when Eugene made his last visit to Alpha Farm, he was greeted by his old friends Caroline, Jim, Lief, Alitia, and Sally. Gathered around them was a handful of hopeful, hard-work-ing young people; a new Alpha Farm generation had arrived.

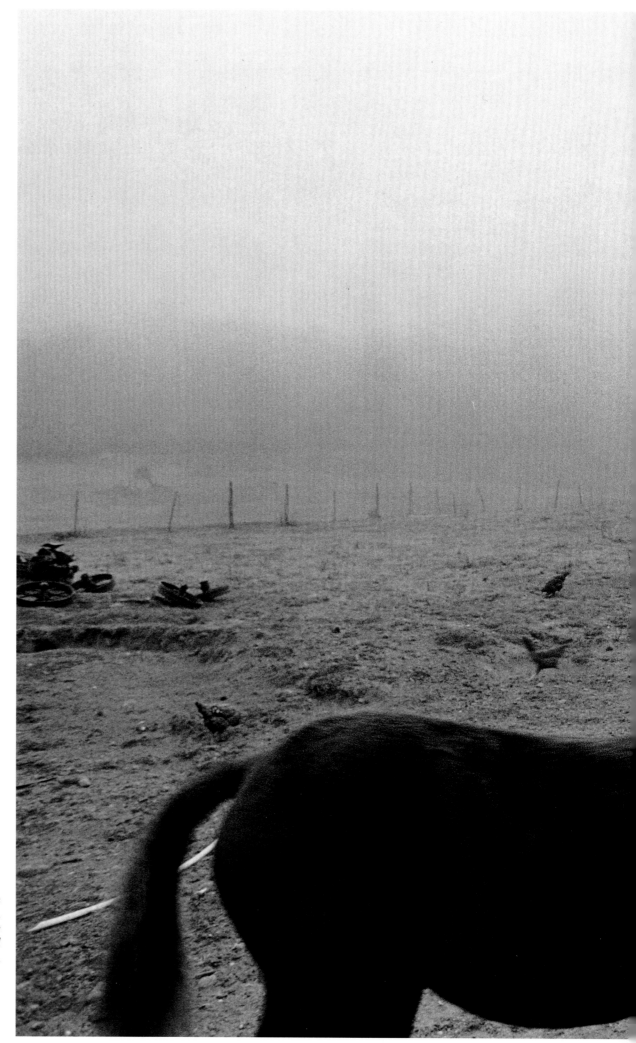

Eugene
Richards,
*The
Original
Barn*,
1991

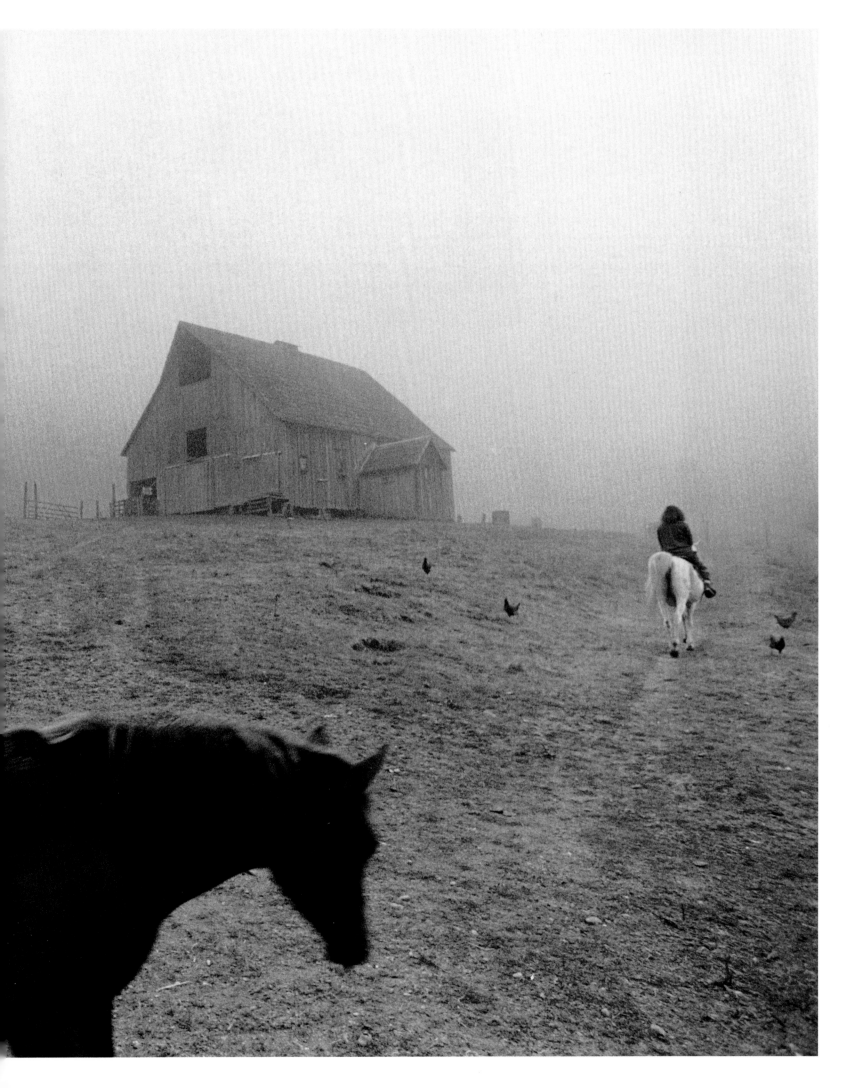

Eugene Richards, *Plowing for the Orchard*, 1991

Opposite top:
Eugene Richards,
Extended Visitors,
1993

Opposite bottom:
Eugene Richards,
*Lilly and Blackie
at Sundown*,
1991

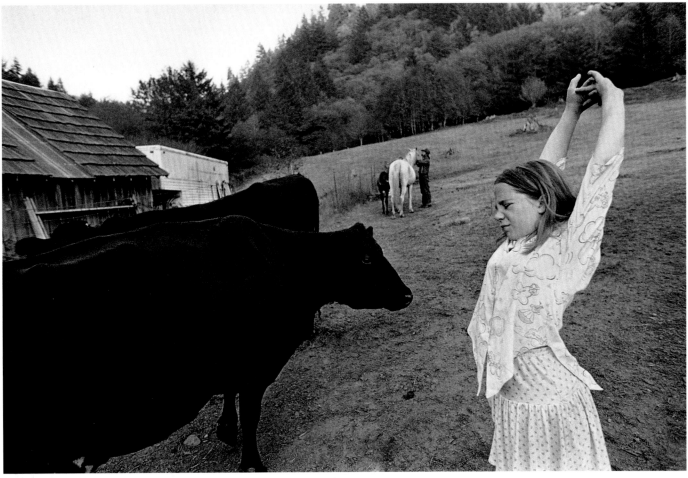

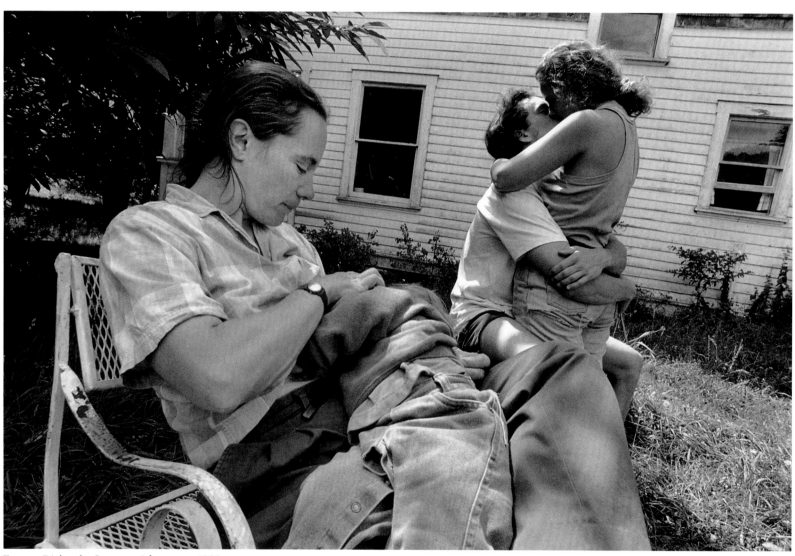

Eugene Richards, *Summer Afternoon*, 1993

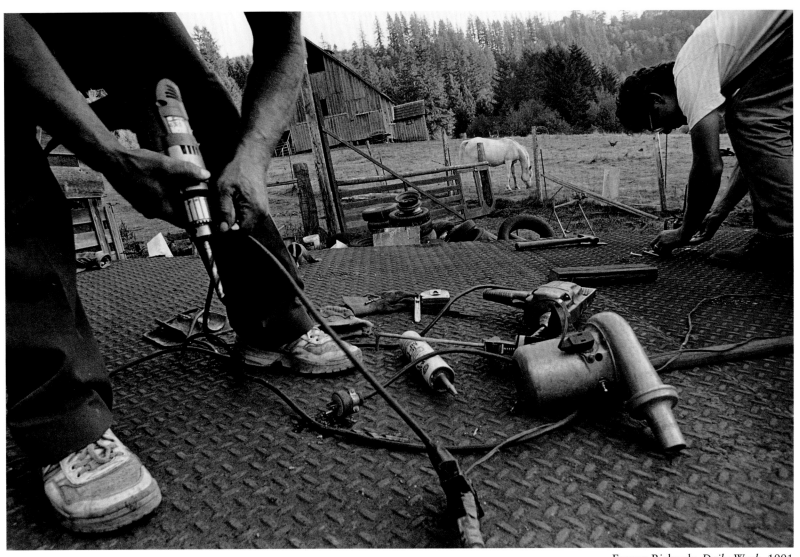

Eugene Richards, *Daily Work*, 1991

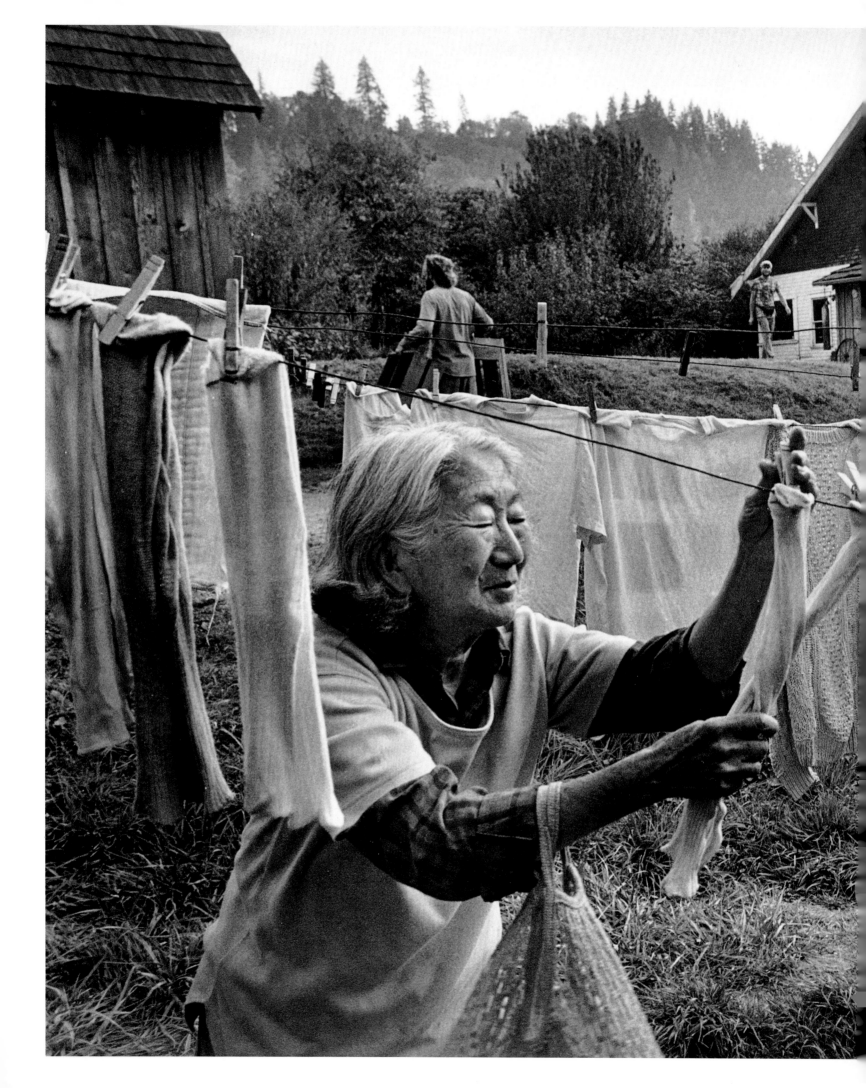

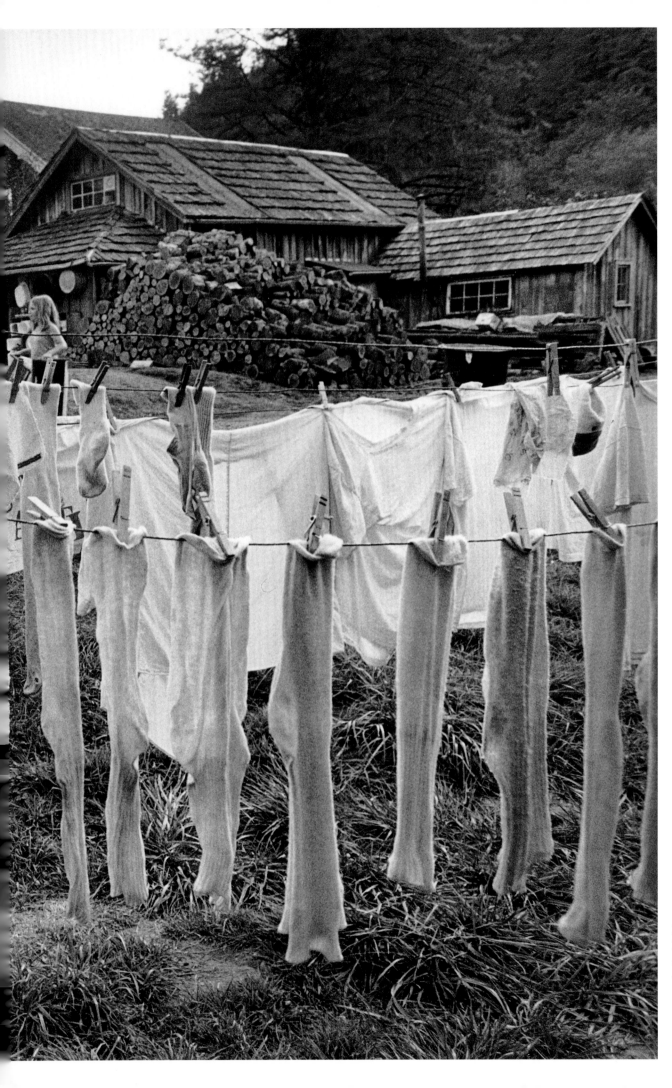

Eugene
Richards,
*May in the
Morning*,
1991

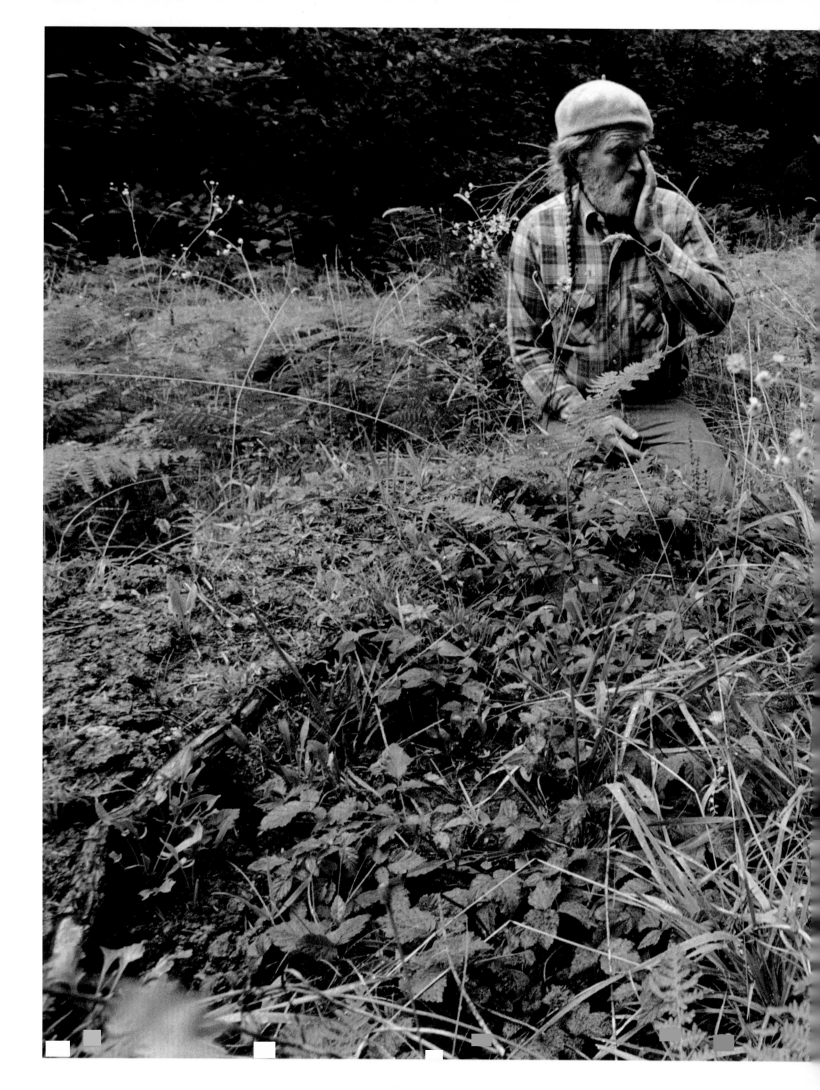

Eugene
Richards,
*Lief at
May's
and Mac's
Grave,*
1993

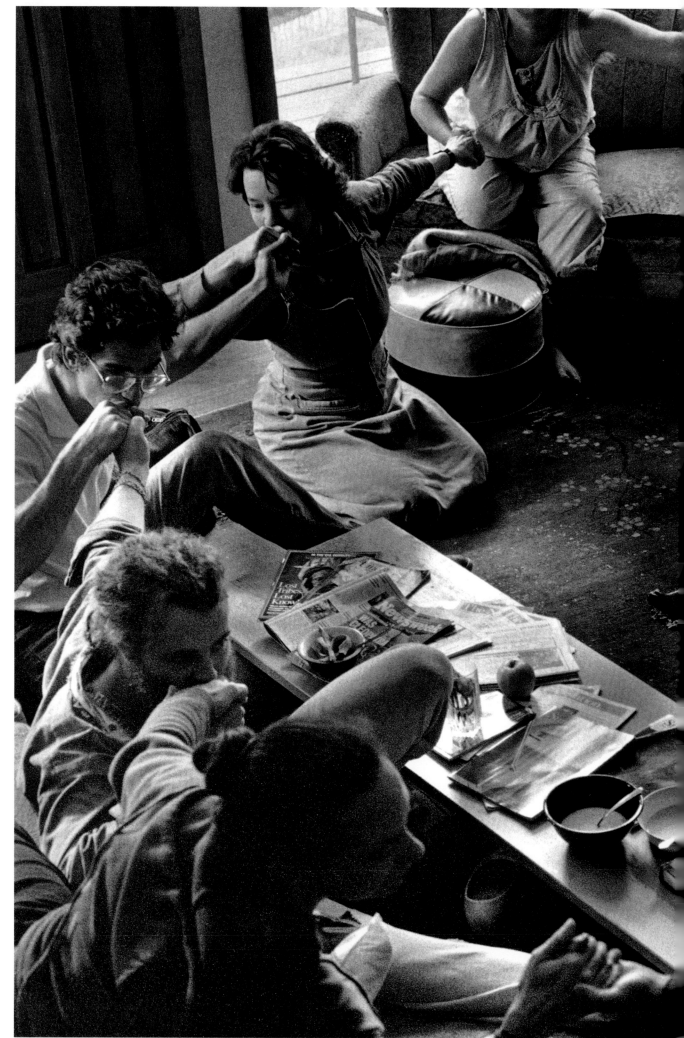

Eugene
Richards,
*End of Third
Meeting,*
1991

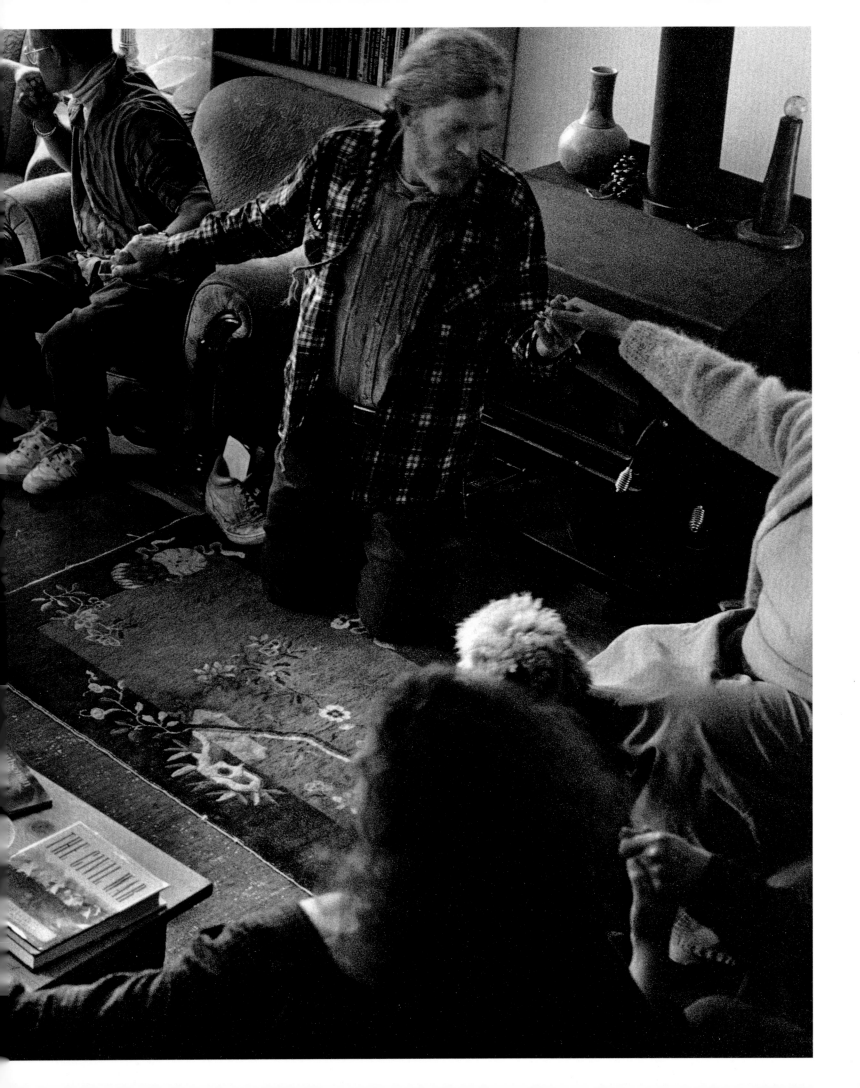

PEOPLE AND IDEAS

GEORGIA O'KEEFFE AT GHOST RANCH: A PHOTO ESSAY, JOHN LOENGARD

Mary-Charlotte Domandi

John Loengard, Georgia O'Keeffe at Ghost Ranch: A Photo Essay. *New York: Stewart, Tabori and Chang, 1995. 80 pages. ($35.00 hardcover).*

In 1966, *Life* magazine sent a young photographer, John Loengard, to New Mexico to photograph Georgia O'Keeffe. By that time she was already an icon. During three days with her he dutifully made images of O'Keeffe and her surroundings that reflected her mythological status—the reclusive, mysterious artist who was, in the popular imagination, as much a part of the southwestern landscape as the hills themselves. *Georgia O'Keeffe at Ghost Ranch* has its solemn, posed photographs of the beautiful, aged artist, dressed in black (her chosen garb for being photographed), starting with the cover image of O'Keeffe in profile against the adobe chimney of her house, all dignity and contemplation, her eyes in shadow, the desert horizon and big sky behind her. There are the expected images of cow skulls, antlers, bones, stones, crosses—the elements of her paintings—and of her famous hands, now old. There are studio shots of brushes, tools, gloves. All this is the material of modern-day hagiography: The artist as saint—wise, untouchable.

But some of the images in the book break this mold and bring O'Keeffe a bit closer. A particularly striking one is of the artist laughing as she leans on her walking stick during her morning walk. No longer posed, or even wearing black, she is suddenly intimate, toothy, an ordinary lady—almost. Another pair of photographs shows O'Keeffe working in her garden, which is surprisingly lush among the desert images. O'Keeffe grew almost all the vegetables she ate in her organic garden. She also made her own bread and did her own canning; she chastised her housekeeper for sneaking out to the store to buy candy bars, which she called "poison."

One is reminded that O'Keeffe grew up on the Wisconsin prairie in the late nineteenth century, on a farm where survival was not assured, and was intimately connected to knowledge of the land. An

John Loengard, *Evening walk, Ghost Ranch*, 1966

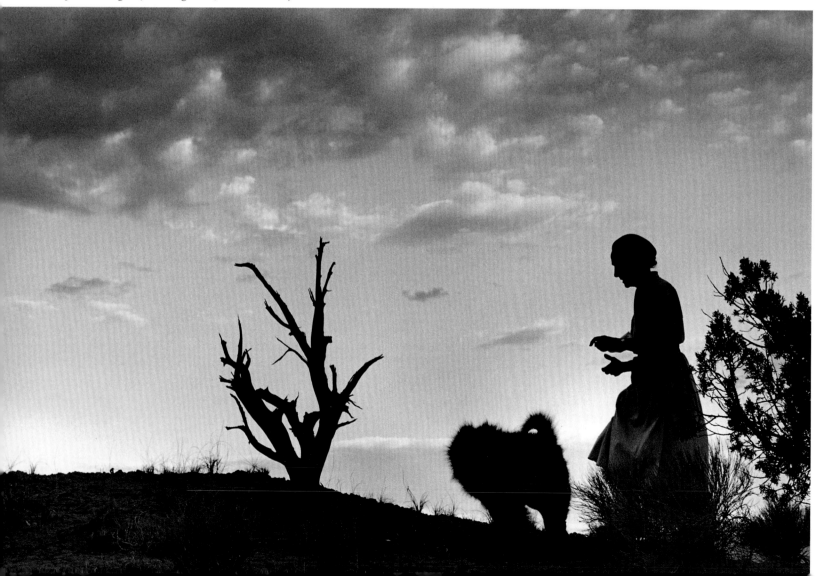

image of O'Keeffe's hand holding a wooden match and pointing to rattlesnake rattles in a small box is made all the more fascinating when we read, in Loengard's introduction, that O'Keeffe killed snakes on her walks.

On her arrival in New Mexico in the summer of 1929, O'Keeffe wrote to her sister, "I am West again and it is as fine as I remembered it—maybe finer—there is nothing to say about it except the fact that for me it is the only place." She traveled with Beck Strand (Paul's wife). They walked around naked and giggling in the sage brush, they painted, learned to drive a car, collected bones, and lived on the ranch of Mabel Dodge Luhan, who was the center of a circle of artists and writers. Back then O'Keeffe was not necessarily revered; Luhan dared to point out her vanity: "That O'Keeffe woman. I just saw her in Taos with her hand hanging out the car window. Ever since Stieglitz made all those photographs of them, she makes sure they are visible at all times."

One misses this irreverence in the images of the older O'Keeffe. One also misses the sense of community. O'Keeffe was no hermit; life in the desert requires interdependence, and she was in fact surrounded by people helping her on all levels. This is what was never photographed: O'Keeffe with all of her friends, family, helpers, associates, fellow artists. She came from a large family and was always close to her sisters (some of them were also talented painters), and their childen and later their grandchildren. They often visited her. In Abiquiu she was surrounded by a Chicano community, to which she paid considerable attention, hiring many people to work for her, spending time with local children, financing college for some, donating money for a town gymnasium and other projects, driving young people to the movies an hour away. The story of her relationships with the people in whose world she lived remains to be written. Was she ever photographed with any of these people, by a serious photographer? Certainly *Life* magazine wasn't going to do it.

Yet it's also true that O'Keeffe liked to be away from people. Loengard shows O'Keeffe with her chow dogs, walking with them, brushing them, sitting near them; sometimes they are shown without

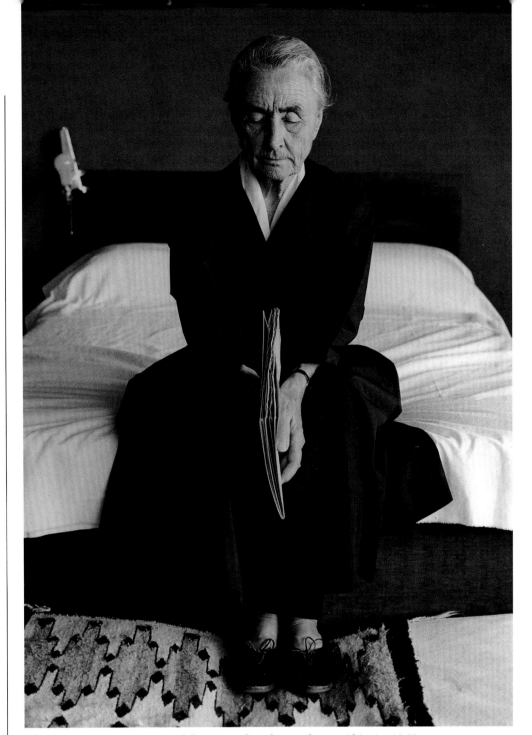

John Loengard, *Holding a Book by Leonard Baskin, Bedroom,* Abiquiu, 1966

her. One of the photographs shows a dog sleeping on her simple white bed, under a Calder mobile. "They seem to belong to adobe," she said when she first got the dogs, and later she called them her "best friends." She saved the hair they shed and had it woven into a shawl.

Loengard's photos of O'Keeffe walking in the landscape are perhaps his best. They show her to be aged but still vital, with a long, striding step whose strength one can feel, without the frailty that was to come later, in her eighties and nineties, when she started to lose her sight and

could no longer take walks by herself. The book begins with her dawn walk along the flat terrain, heading into a dark wall of desert cliffs, and ends with her evening walk with the two dogs along a ridge, heading out toward the Pedernal mesa that she made famous. In them, one feels O'Keeffe as the woman who could listen to the language of the wind, of the mountains, of her dogs, of the sky. She is shown smaller and the land bigger, and in that proportion there is a sense of the artist that transcends the icon—a great woman, tiny, absorbed by the vast desert.

ALFRED STIEGLITZ: A BIOGRAPHY, RICHARD WHELAN

Robert Adams

Richard Whelan, Alfred Stieglitz: A Biography. *New York: Little, Brown and Co., 1995. 672 pages.* ($29.95 hardcover).

We are grateful to Alfred Stieglitz for at least three contributions: the changes he helped bring about within the American art establishment, the photographs he took, and the support he offered, by the example of his life, for a sense of community. Richard Whelan's biography focuses on the first of these contributions—Stieglitz's work on behalf of modern art, in which he included photography. Whelan covers a lot of ground, describing conflicts and friendships, shows and publications. He does this with the skill of an accomplished narrator, and he is particularly able in establishing social and intellectual context. The book will be of interest primarily to scholars, but there are elements in it that will speak to a wider audience. It is a relief to discover, for instance, that Stieglitz at first disliked Cézanne's watercolors, pictures that are now among the most admired: even a prophet needed time to grow. And there are funny details (Stieglitz was, it turns out, an enthusiast for miniature golf) along with entertaining stories, such as one about Big Bill Haywood visiting the gallery *291*, and urging an indignant Stieglitz to "leave this place and join the real fight." There are, too, anecdotes that will make any artist wiser, including a description of Stieglitz selling 8,000 unsold copies of the magazine *291* to a ragpicker for $5.80.

Unfortunately Stieglitz's photographs are not given the attention that they deserve. The author seldom deals with specific pictures, and when he does he often moves quickly to reductive analyses—if the subject of a portrait looks happy or sad, then, Whelan suggests, this must have been the way life was going at the time for the photographer. On other occasions Whelan is short on the critical apparatus needed to explore visual achievement, as when he writes that "the great theme of Stieglitz's 1910 work is the juxtaposition of striking contrasts and similarities—of related forms, of light and dark, of the old

and new." Contrasting light and dark does not amount to a "theme" unless one believes that Stieglitz's goals were purely formal, which they were not.

Whelan does understand, however, that the pictures are important, and he occasionally makes this clear. The late New York City views, for instance, bring him to quote with approval an assessment by Harold Clurman, who described the scenes as "crowded, immutable, and terribly, terribly deathlike. . . . It is a city in which man has almost completely disappeared; despite all its metallic precision, it is like an enormous graven image of some very ancient civilization in which all signs of humanity have withered and everything is wrapped in silence." By implication the pictures were and are a key to understanding ourselves as a nation, and, it follows, they help us to understand Stieglitz and the burden he embraced of our country's hope and failure.

At some point, one that is never reached in the book, we naturally ask whether photographs that are this visionary may counterbalance the failures in Stieglitz's life—the unkindnesses and follies that resulted from his egoism—just as we tend to judge Robert Frost's bad behavior pardonable after we read miracles like "Stopping by Woods on a Snowy Evening" or "Nothing Gold Can Stay." We forgive artists a great deal, if reluctantly, when their work is so nearly perfect. Which means that in an artist's biography it is essential to keep the work somehow in view.

It can be argued, certainly, that there isn't much to say about great pictures—that they are great in part because they are already clear—and so a biographer might be wise not to try. But to the extent that this is true, a biography should reproduce, in good quality, an ample selection of the pictures. Here, however, we are given only a few, and these jammed together and reproduced miserably.

In the text Whelan is reasonably fair but infrequently forgiving. Stieglitz was an easy man to dislike, and Whelan seems not to resist the inclination, sometimes

Paul Strand, *Alfred Stieglitz,* Lake George, New York, 1929

even indulging in gratuitous insults, as when he describes an incident in which Stieglitz saved two people from drowning, and follows with the observation that in so doing Stieglitz "must have surprised even himself."

Stieglitz's problem, in Whelan's opinion and in that of many of Stieglitz's detractors, was "that anyone who disagreed with him must be selfish or blind. This attitude was a fatal flaw—in his relations with those he loved, with artists, with collectors, with the critics, with dealers and curators, and with the public." But Whelan makes the case too extreme. The weakness, which was indeed a crippling handicap, was not "a fatal flaw" in his relationships with Georgia O'Keeffe and Dorothy Norman and many others who continued to respect him despite the shortcoming.

No biographer should obscure defining transgressions, but it is usually helpful to admire something enough in your subject so that you forego a full list of repetitive follies. The biographer needs to do this so that what he or she affirms in the subject—what makes writing (and reading) a biography of more than six hundred pages worth the effort—can be kept clearly in view.

One unfortunate result of adopting so hard an attitude toward Stieglitz is to

make baffling the positive opinions held of him by many others. Are they just foolish? We wish that Whelan's judgment might have been as complex and enabling as was O'Keeffe's at the end: "I could see his strengths and weaknesses. I put up with what seemed to me a good deal of contradictory nonsense because of what seemed clear and bright and wonderful."

Whelan's generosity is also limited, regrettably, when he comes to Dorothy Norman. We are infrequently encouraged to see her relationship with Stieglitz from her perspective. This may—I have no way of knowing—reflect some difficulty in presenting her perspective without her full cooperation (she is now over ninety and, as Stieglitz and O'Keeffe were, a strong individual), but the effect of minimizing her point of view is to suggest a negative assessment of her role in Stieglitz's life, an assessment that seems too harsh. Even Dante, after all, placed illicit lovers only just barely inside hell, the offense being close to virtue.

O'Keeffe on the other hand emerges as a heroine, which is understandable as she was courageous and gifted and articulate, but the portrait is selective. Whereas, for example, Whelan holds up for implied criticism some weak poetry by Norman, he makes no point of the fact that O'Keeffe produced, along with some wonderful paintings, a striking quantity of banal work.

In general the shortcomings of this biography—relatively too little attention to Stieglitz's pictures, and relatively too much to his egoism—have contributed, I think, to a lost opportunity. Because Whelan disapproves of Stieglitz in so may ways, he largely misses the importance of Stieglitz's life as a whole and as an example (significantly, he offers at the close no broad summary that might lead readers to such an understanding). At his best, Stieglitz saw his work as a calling, an obligation to a kind of service, a vocation rather than a career; and today, after Reaganism and its mirror image in so much of the art establishment, his efforts point constructively toward an alternative that we need to rediscover. Stieglitz wanted to use art as a basis for community. On a small scale, intermittently, imperfectly—he succeeded. Not bad.

TINA MODOTTI: PHOTOGRAPHS, SARAH M. LOWE

Susan Morgan

Sarah M. Lowe, Tina Modotti: Photographs. *Introduction by Anne d'Harnoncourt. New York: Harry N. Abrams, Inc. in association with the Philadelphia Museum of Art, 1995. 60 pages.* ($45.00 hardcover).

In 1942, soon after Tina Modotti's unforeseen death—at forty–five, of reported heart failure while riding in a Mexico City taxi—a memorial exhibition was organized by a group of Republican Refugees from the Spanish Civil War. Modotti was commemorated as a comrade in the ongoing fight against fascism and fifty of her photographs were presented at the Galeria de Arte Mexicano. Starting with this exhibition, a recurring cultural eclipse was set into motion—for nearly fifty years, Modotti's formidable life would too often overshadow the reception of her extraordinary oeuvre.

Now, in the first retrospective of her work, collaboratively curated by art historian Sarah M. Lowe and the Philadelphia Museum of Art's Associate Curator of Photographs Martha Chahroudi, Modotti's elegant and rigorous photographs are given not only well-deserved attention but

Tina Modotti, *Calla Lilies*, 1925

also a context that acknowledges her exacting aesthetics and modernist vision.

The story of Modotti's life reads like an inspired collaboration between Lawrence Durrell and Graham Greene: during the 1920s, she was an actress in Hollywood silent movies, a documentarian of the Mexican mural movement, a commercial portraitist, a conspiracy suspect in an alleged assassination plot, an exile in Weimar Germany, a translator for magazines including the New York socialist weekly the *New Masses* and Berlin's *Arbeiter Illustrierte Zeitung* (Workers' Illustrated News), and a Moscow courier for the Communist party. Through Edward Weston's disarmingly intimate portraits (Modotti was one of the few models whose face Weston photographed), Modotti became familiar to the public. These images miscast her as simply the artist's lover, model, and muse. She was also, however, his partner in a photography studio. With her far-ranging experiences and flair for languages—she spoke Italian, English, Spanish, and German—Modotti was far more culturally sophisticated and politically progressive than Weston. Earlier Weston credited the photographer Margarethe Mather with influencing his thought and work; similarly, his education as an artist was in many ways indebted to Modotti.

For a 1982 exhibition that originated at London's Whitechapel Art Gallery, Modotti's photographs were paired with Frida Kahlo's paintings. The opportunity to see Kahlo and Modotti's work, both woefully underexhibited at the time, was thrilling. But in the selective manner of ardent theorists, the curators Laura Mulvey and Peter Wollen characterized the artworks to serve the demands of their own particular arguments. "The art of both Kahlo and Modotti had a basis in their bodies," they stated in their catalog essay. "Through injury, pain, and disability in Frida Kahlo's case; through an accident of beauty in Tina Modotti's." It was their claim that "both [Modotti and Kahlo] produced work that is recognizably that of a woman." For Wollen and Mulvey's purposes, Modotti's break with Weston allowed her to return to documentary

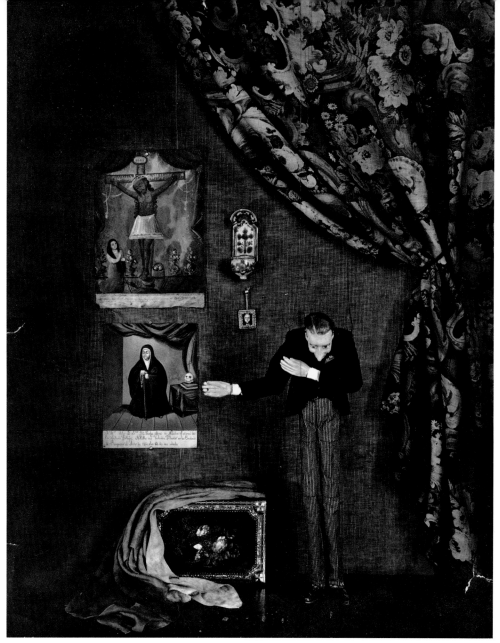

Tina Modotti, *René d'Harnoncourt Marionette*, 1929

found sense of simplicity and a direct and respectful regard. Among the 120 images included in this retrospective are portraits, propagandist photomontages and still lifes, abstract compositions, and a range of commissioned editorial work—from documentation of Mexican toys and masks to illustrations—beautifully minimal compositions of an enormous black storage tank, a tall skeletal ladder, and a dense cross-hatching of steel girders—made to accompany poetry written in support of the *Movimento Estridentista* and its creed of praising "the modern beauty of the machine." Within each image, the clarity of Modotti's gaze is revealed.

Modotti's photographs are strikingly loose in time. Writing about Modotti's work in 1929, Carleton Beals compared the lilies to Fra Angelico's angel trumpets depicted in a pale gray dawn; an abstract composition of crumpled tin foil, a metallic arrangement of light and shadow, provides a missing link between Stieglitz's well-known "Equivalents" and James Welling's tin-foil studies of the early 1980s; "*flor de manita*" with its blossom like a gnarled hand, the heavy petals of a fully bloomed rose, and a pair of calla lilies gracefully arching away from one another—define an elegance sampled years later by Robert Mapplethorpe.

Tina Modotti: Photographs provides, at last, a thorough and considerate presentation of a brief but impressive career. Venturing beyond Modotti's more familiar images (the heavy roses, the nursing mother, the string-tangled hands of the puppeteer), there are wonderful surprises: a stand of sugar cane closely cropped into linear abstraction, a vertiginous view down a flight of wooden stairs, and a marvelous scene, set on a miniature stage, featuring a long-legged marionette version of René d'Harnoncourt (the Austrian-born artist who later became the director of Museum of Modern Art), decked out in a morning suit, taking a lithesome bow.

At the close of her compelling text, Lowe points out that a self-portrait of Modotti, long since lost, was included in the 1942 memorial exhibition. "How did Modotti see herself?" Lowe asks, knowing there is no answer. But how Modotti saw the world is evident—she was a modernist endowed with remarkable compassion.

photography devoted only to the body-related images of women, children, and workers. The astonishing images presented in that show, however—delicately shaded architectural studies with distinctly Cubist undercurrents, an angel's eye view of a typewriter scrolling out a revolutionary statement by Leon Trotsky, splayed lines of telephone wires casting a musical staff against the sky—implicitly contradict the limitations of the curators' thesis.

And now we have the current retrospective and Sarah Lowe's impressively comprehensive study of Modotti's life and work (published by Abrams in conjunction with the Philadelphia Museum). Lowe's research both introduces new biographical information, and establishes Modotti's work within a broader social history. "Modotti recognized photogra-

phy as the medium of modern literacy," writes Lowe. "And grasped its potential in shaping culture and politics."

Modotti produced photographs over a period of less than ten years; between 1923 and 1930 she worked in Mexico, shooting primarily with a 3 1/4" x 4 1/4" Graflex. After she was deported from Mexico in 1930, she went Berlin. Writing to Edward Weston, she said, "(here everybody uses a camera) and the workers themselves make those pictures [propaganda] and have indeed better opportunities than I could ever have, since it is their own life and problems they photograph. Of course their results are far from the standard that I am struggling to keep up in photography, but their end is reached just the same."

Modotti's standards were committed to an essential formalism conveying a pro-

IN MEMORIAM, BRIAN WEIL

Philip Yenawine

On February 5, 1996, the photographer Brian Weil was found dead in his apartment, apparently from pneumonia complicated by illegal drugs. The media made much of the tragedy, seeing irony in the fact that Brian pioneered now-heralded efforts to get clean paraphernalia and other services to users in Harlem and the Bronx, thus preventing the spread of AIDS. He was instrumental in protecting the lives of countless people who take drugs intravenously, and in the midst of it he somehow lost his own.

Helping people through the New York Harm Reduction Educators and, more recently, City Wide Needle Exchange was a twenty-four-hour-a-day mission for Brian, and it was also a source of information about human behavior, including the capacity for self destruction—and for survival. The world in which he was enmeshed introduced him to people on street corners, seedy hotels, bar rooms, and back rooms around the world; occasionally they became the subjects of his art.

His best known pictures are of people with AIDS (published by Aperture in *Every 17 Seconds: A Global Perspective on the AIDS Crisis*, with an introduction by Simon Watney) but, uninterested in simply bearing witness to their lives, Brian shot rarely, selectively, and only when an image could exist as testimony to friendships with people written off by most of us. His work offers impressions of persons living in trouble-filled worlds and with disease, carrying on activities that we don't often see or like to acknowledge. The pictures are intimate, gritty, disturbing, behind-the-scenes views, but they are not records of decay. Instead, they are portraits of the courage, grace, and intelligence with which his friends faced and sometimes transcended difficult lives.

Regardless of the different subjects, much of Weil's work has common visual qualities resulting from a combination of unusual lighting, the technically "inappropriate" film he often used, and additional alterations he might make directly on the film—scratching it, for example before he printed. His point was to evoke rather than to describe, and he challenged conventional ideas of what makes a "good" picture. As a result, he may have more fans in the extended world of art than he does in photography, although he was a much-beloved teacher at the International Center of Photography, especially by people working in the area of social engagement and technical innovation.

He made work in series, almost always as a result of his perpetual immersion in a culture he found intriguing, usually because it was on the fringes of society. One series focused on homicides: he wrote to police departments in a number of major cities, and only Miami would let him accompany officers as they investigated crimes while he photographed the scene. He stayed in Miami for weeks at a time, barely sleeping in order to ride with the police on as many calls as possible. He was a seeker of truth, of the moment when seeing provokes knowledge; it is unfortunate that few of these images were ever produced for presentation.

He made similar rich studies of Hasidim, virtually living among them until he learned enough to make honest, realistic, compassionate portraits. At another point, he advertised in various journals, seeking people who were into bizarre sexual practices, including bestiality, and who wanted to be photographed in action. When people would respond, he would correspond with them extensively before meeting them. If, after ongoing communication he decided to take any pictures, he used a Super-8 movie camera. The few images he finally showed were enlarged film stills, indistinct and evocative. His last artwork was mostly in video, and resulted from friendships with cross dressers and transsexuals, who responded with candor to his non-judgmental interest in helping them present their points of view.

He viewed a scene through his lens, and again in his darkroom, searching for the moment when something dark becomes the substance of insight, when the light on a tough subject illuminates the shared points of humanness that leave behavior and circumstances behind.

Brian Weil, ACT UP demonstration, Bethesda MD., 1990

Brian Weil, *Untitled*, 1986, from "The Hasidim"

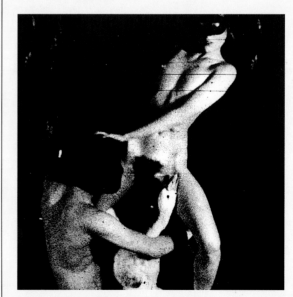

Brian Weil, *Untitled*, 1977/80, from the "Sex Series"

CONTRIBUTORS

ROBERT ADAMS is an independent photographer and writer whose publications include: *West from the Columbia: Views at the River Mouth, Listening to the River: Seasons in the American West*, and *Why People Photograph*.

JANINE ALTONGY is a free-lance researcher, writer, and producer whose book projects include: *Below the Line: Living Poor in America*, and *Homeless in America*. Her writing has appeared in the *Independent on Sunday, Gioia, Nieuwe Revu*, and *Tempo*.

REBECCA BUSSELLE is the author of *An Exposure of the Heart,* a book about the year she spent photographing at Wassaic Developmental Center. She serves on the board of Potential Unlimited, Inc., which promotes collaboration between professional musicians and performers with developmental disabilities.

MARY-CHARLOTTE DOMANDI is a writer and novelist who also produces audio programs for museums. She holds a B.A. in art history from Yale, a Masters in Liberal Education from St. Johns College, and studied fine arts at the Institute of American Indian Arts.

IAN HANCOCK is a delegate to the United Nations and UNICEF for the Romani Union, President of the International Roma Federation, Inc., and a member of the Project on Ethnic Relations, Romani Advisory Council (Princeton University), and the Anne Frank Institute. Author of *A Handbook of Vlax Romani* (Slavica Publishers, Inc., Columbus, 1995), Dr. Hancock is currently Professor of Romani Studies at the University of Texas, Austin.

SUSAN MORGAN is a contributing writer at *Elle* and *Mirabella*, the author of the 1992 Aperture monograph *Martin Munkacsi*, and a contributor to the 1995 Aperture monograph *Edward Weston Portraits*.

MARGARET MORTON is an associate professor of art at The Cooper Union School of Art. Her ongoing project, "The Architecture of Despair," has received numerous grants and has been published in the books *Transitory Gardens, Uprooted Lives*, and *The Tunnel: The Underground Homeless of New York City* (both, Yale University Press, 1993 and 1995).

CORNELIUS M. PIETZNER is President of the Camphill Association of North America. His photographs have been published in a number of books including *Village Life—The Camphill Communities*, for which he also served as editor.

STEPHAN RASCH's photographs have appeared in numerous publications, including *Village Life*, the *Bio-Dynamic Journal*, the *East West Journal, Parade Magazine* and the *New York Times Sunday Magazine*. He is a musician and teacher at one of the Camphill communities.

EUGENE RICHARDS, a free-lance photographer, writer, and teacher, is the author of eight books, including: *Below The Line: Living Poor in America; Cocaine True, Cocaine Blue;* and *Americans We*. Among his many awards are the Leica Medal of Excellence (1988 and 1991) and the Kodak Crystal Eagle Award for Impact in Photojournalism (1992).

CRISTINA SALVADOR, a former staff photographer at the *Long Beach Press-Telegram*, is currently a free-lance photographer. Among her awards is a 1993 National Endowment for the Arts photography grant for "The Roma."

LARRY TOWELL is a free-lance photographer and writer whose photo essays have appeared in *LIFE*, the *New York Times*, *GEO, Rolling Stone*, and *Esquire*. *Mennonites* will be published by W.W. Norton/Duke University in 1997.

LAURA WILSON is a photographer from Texas whose work has appeared in the *New Yorker*, the *London Sunday Times*, the *New York Times Magazine*, and *Texas Monthly*. In 1989, she completed *Watt Matthews of Lambshead*, a book about one of the last great Texas cattlemen.

PHILIP YENAWINE is a partner in Development Through Art. The Director of Education at the Museum of Modern Art from 1983 to 1993, he has also served as a visiting professor of art education at Massachusetts College of Art.

CREDITS AND ACKNOWLEDGMENTS

Note: Unless otherwise noted, all photographs are courtesy of, and copyright by, the artist.

Front cover photograph and pp. 2–13 by Laura Wilson; pp. 14–25 by Cristina Salvador; pp. 26–35 by Cornelius M. Pietzner and Stephan Rasch; pp. 36–45 by Margaret Morton, courtesy of Simon Lowinsky Gallery, NYC; pp. 46–59 by Larry Towell, courtesy Magnum Photos, New York; pp. 60–73 by Eugene Richards; pp. 74–75 by John Loengard; p. 76 by Paul Strand, copyright © Aperture Foundation, Inc.; p. 77 by Tina Modotti, courtesy the Philadelphia Museum of Art, The Detroit Institute of Arts, Founders Society Purchase, Abraham Borman Family Fund; p. 78 by Tina Modotti, courtesy the Philadelphia Museum of Art, collection of Andrew Masullo; p. 79 all photographs copyright © the Estate of Brian Weil, left and middle images collection of Ann Philbin, right image courtesy of Wooster Gardens/Brent Sikkema.

Special thanks to: Drawing Center/Ann Philbin, New York; Julia Rasch, Associate Director, Camphill Village, Copake, New York; Adam Reich, Wooster Gardens/Brent Sikkema, New York; David Strettle, Magnum Photos, New York; Carolyn Goldstein, National Building Museum, Washington, DC.